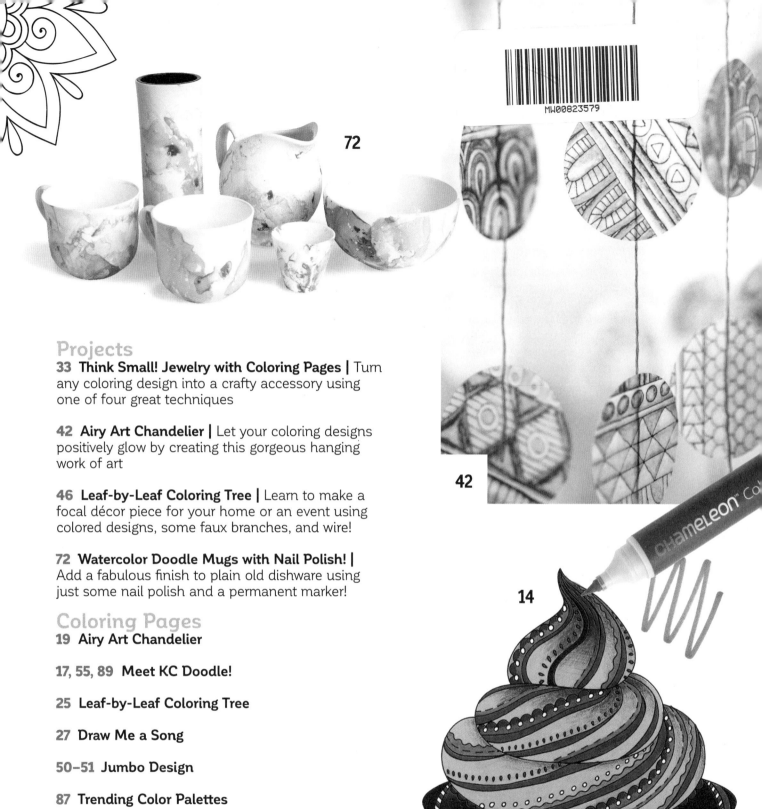

72

42

14

Welcome!

We've had an entire year of fun here at *DO Magazine*, with you readers supporting us every step of the way with our first four issues. Now, with that year under our belt, we're nowhere close to running out of ideas! And that's a good thing, because the coloring "trend" is here to stay. In fact, soon we won't be calling it a trend anymore—it will just be a healthy, happy, fun hobby like any other. And that means widespread awareness, more great products, more coloring books, and—of course—more years of this magazine. With 5,900 and counting coloring books published since January 2016, we'll be rolling out our Fair Trade Seal of Approval to other publishers, and continuing to spotlight the best new books and products. And though there's room in the trend—or, rather, the hobby—for all tastes, from wholesome to humorous and from sophisticated to snarky, here at *DO* we are all about positivity and creativity, about ways to energize and invigorate your love of coloring. In that vein, this issue is chock full of innovative ideas for using your coloring and doodling talents to make mugs, chandeliers, rings, and more. It's just one way of showing how the coloring community continues to push its own limits. So jump in and enjoy!

The DO team

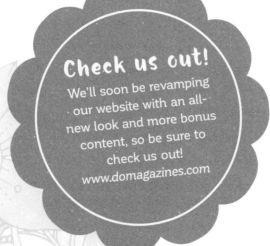

Check us out!

We'll soon be revamping our website with an all-new look and more bonus content, so be sure to check us out! www.domagazines.com

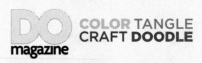

COLOR TANGLE CRAFT DOODLE

Design Originals Presents DO Magazine, Fall 2016
Volume 2, Number 3, Issue 5 | www.domagazines.com

Design Originals: DO Magazine – Color, Tangle, Craft, Doodle
1970 Broad Street, East Petersburg, PA 17520
Phone: 717-560-4703 | Fax: 717-560-4702

Our mission: To promote coloring, drawing, pattern ornamentation, and tangling for enjoyment and health.

PUBLISHER — Carole Giagnocavo

ASSOCIATE PUBLISHER — Peg Couch

CONTRIBUTORS

Katy Abbott	Kate Lanphier
Krisa Bousquet	Nick Mayer
Marie Browning	Thaneeya McArdle
Filippo Cardu	Valerie McKeehan
Kati Erney	Llara Pazdan
Joanne Fink	Robin Pickens
Carole Giagnocavo	Deb Strain
Kayomi Harai	Nour Tohmé
Valentina Harper	Angelea Van Dam
Ben Kwok	Nichole Warman

EDITORIAL STAFF

Colleen Dorsey
Katie Weeber
Kati Erney

LAYOUT AND DESIGN STAFF

Kate Lanphier	Justin Speers
Llara Pazdan	Lindsay Garner
Wendy Reynolds	

PROJECT DESIGN

Llara Pazdan
Kati Erney
Kate Lanphier

Customer Service for Subscribers
Visit www.domagazines.com, call 800-457-9112, or write: DO Magazine, 1970 Broad Street, East Petersburg, PA 17520

Newsstand Distribution: Curtis Circulation Company
Circulation Consultant: National Publisher Services
Printed in USA.
©2016 by New Design Originals, Inc. All Rights Reserved.

Subscription rates in US dollars:
One year $39.95
Canada | One year $44.95
International | One year $49.95
Wholesale/Distribution
DO Magazine: Color, Tangle, Craft, Doodle is available to retailers for resale on advantageous terms. Contact Sales Support for details: 800-457-9112 Ext. 105 or sales@foxchapelpublishing.com.

Identification Statement: DO Magazine (Fall 2016) vol. 2, no. 3
DO Magazine is published quarterly by Fox Chapel Publishing Co. Inc., 1970 Broad Street, East Petersburg, PA 17520
Application to mail at periodicals postage prices is pending at Lancaster, PA and additional mailing offices.
POSTMASTER: Send address changes to DO Magazine, 1970 Broad Street, East Petersburg, PA 17520.
Note to Professional Copy Services — The publisher grants you permission to make up to ten copies for any purchaser of this magazine who states the copies are for personal use.
COPY PERMISSION: The written instructions, photographs, designs, patterns, and projects in this publication are intended for the personal use of the reader and may be reproduced for that purpose only. Any other use, especially commercial use, is forbidden under law without the written permission of the copyright holder.
"Zentangle®," the red square, and "Anything is possible, one stroke at a time" are registered trademarks of Zentangle, Inc. The Zentangle teaching method is patent pending and is used by permission. You'll find wonderful resources, including a list of workshops and Certified Zentangle Teachers (CZTs), at zentangle.com.

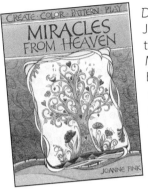

DO Magazine contributor and coloring book author Joanne Fink recently collaborated with Sony Pictures to run a coloring contest in promotion of the movie *Miracles from Heaven* with a companion coloring book. What she didn't know was that only residents of the US would be eligible to participate. This was disappointing to her, considering that her art brand Zenspirations® is globally known and more than 50 countries are represented in the Zenspirations Facebook group alone. (For more info, visit www.zenspirations.com.) So she came up with the perfect solution: her own coloring contest, exclusively for international colorists, where the prize is to be featured in a future article in *DO Magazine* about Color & Creativity Enthusiasts (the name for the community of artists who color, pattern, and adapt Joanne's work). The winner was **Helga Cuypers of Belgium**, who submitted this stunningly subtle piece of art. So look for the article in a future issue, and also look for more of Helga's work in various coloring books by Joanne Fink, Robin Pickens, Brenda Abdoyan, and other authors—she does lovely work with all kinds of art!

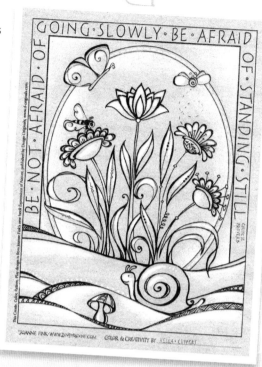

Here at *DO Magazine* we pepper you with interesting coloring ideas, techniques, and products all the time, but get ready for THE essential book on how to color, coming in fall 2016! It's called *New Guide to Coloring*, and everyone from novices to experienced colorists will learn a lot from it... so get excited!

Send Us Your Work!

Email or mail us your awesome finished pieces from the magazine (or photos of your crafty work) and we might just feature you in a future issue! If we feature you, we'll send you a cool surprise. Send your work to **editors@domagazines.com** or to **DO Magazine**, 1970 Broad Street, East Petersburg, PA 17520, and don't forget to include your contact info! You can also post to our Facebook page (**www.facebook.com/DOMagazineColorTangleCraftDoodle**) or tag us on Instagram (**@domagazines**); use the hashtag **#DOMagazine**.

You love our guided coloring pages! Says Doreen L. of Connecticut, "Just wanted to let you know that by including these palettes in your magazine, I decided to subscribe. We can get into 'color ruts' and not try out new color combinations. Your suggested color palettes are a great way to get a newbie like me to venture on new color paths. Thank you!" We're glad you like them, Doreen! There are several guided pages in this issue—flip through to find them all!

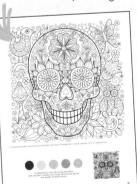

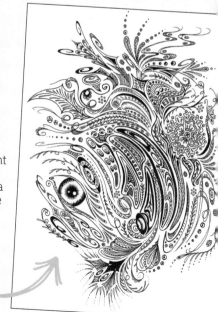

Amber K. of Vermont picked up her first *DO Magazine* at a Tractor Supply store and was inspired by the Zentangle and doodly grids articles to create some gorgeous abstract pieces of art. Amazing work, Amber!

Social Coloring!

A quick look at a new phenomenon: COLORING CLUBS

Social coloring clubs have been popping up on our radar lately. Here's a rundown of what's been going on in this new world of connected coloring.

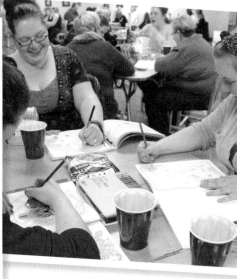

Some shots from recent *DO Magazine* coloring events in central Pennsylvania.

How can I find a club? Start by checking at libraries, senior centers, rec centers, and churches—these are common places where coloring clubs are springing up. Visit www.coloringbookday.com for a listing of existing clubs by state. Don't forget that you can have a digital club as well, if you can't find a club in your geographic area—check online and on Facebook, because there are online coloring groups to suit all styles and tastes!

How can I start my own club? First, try visiting some of the locations mentioned above and talking to the managers to see if there is interest. Then you'll have a venue! Put out the call on your social media, email your friends and tell them to email their friends, and even try posting flyers at libraries or on other public billboards. You might be surprised how much interest there is! If you want to start small to gauge interest, try hosting a casual coloring night at your house. Some people might be hesitant to join a club, but we're sure they'll show up for a party! Check out the article on page 68 to learn more.

National Coloring Book Day is August 2!

So don't forget to share your art on social media or have a coloring party to celebrate the event! Visit www.coloringbookday.com for a listing of existing clubs by state.

DO MAGAZINE SURVEY RESULTS

More than 450 of you responded to our survey in April—thanks so much! We found that there is definitely increasing interest in coloring clubs, and people want to learn more. Expect the number of coloring clubs to grow!

coloring club comments

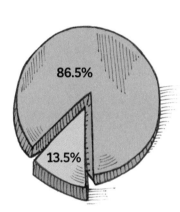

86.5%

13.5%

Are you in a coloring club?

- Yes
- No

"We meet and color at our local rec center."

"I've started an afterschool coloring club with my middle school students."

"I'm an activities director, so my job allows me to color with our residents as a scheduled activity."

"Wish I could find a coloring club nearby."

"I might be interested in a club if I knew of one in my area."

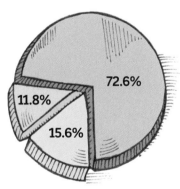

72.6%

11.8%

15.6%

Are you thinking of joining or starting a coloring club?

- Yes, starting
- Yes, joining
- No

"I manage a coloring club at my public library—we meet once per month for two hours. It's fun!"

"Our group meets to color and do Zentangle at the local senior center. The resident seniors seem to like it when we show up."

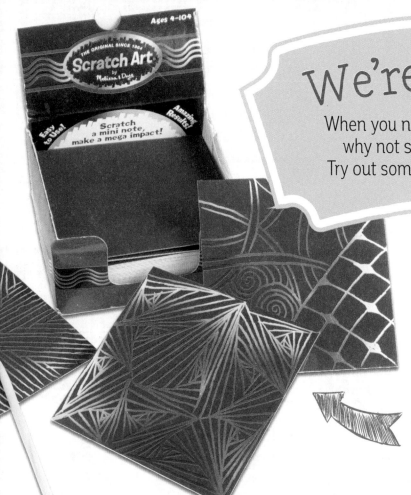

We're Loving It!

When you need to beat the summer heat, why not stay inside to craft or color? Try out some of our newest favorite toys!

Scratch Art Rainbow Notes: These sturdy, square 3½" notecards are so simple and fun to use. I decorated some with my seven-year-old niece, and her enthusiasm was just infectious. They're super portable, and you can use anything, like a coin or a paper clip, to scratch your designs. It's a quick and satisfying way to do coloring without a coloring page. Plus, it's perfect for random acts of Zentangle or art that you leave for other people to find. Admit it—you want a pack! ($7.99, *www.melissaanddoug.com* and in many stores)

—**Colleen Dorsey, Editor**

Polychromos Colored Pencils: I'm beyond crazy about Faber-Castell's Polychromos line of colored pencils. These professional-grade oil-based artist pencils are soft and sturdy for a remarkable coloring experience, and I love how vibrant and smooth the colors are. Polychromos pencils can be purchased individually and in variously sized sets for beginner experimentation, or in a limited edition wood case of 120 pencils for those of us who know what we love and aren't afraid to splurge on it! ($32.25 for 12-pack or $2.85 per pencil, *www.faber-castell.com*)

—**Nichole Warman, Designer**

PHOTO COURTESY LISA CARYL

Zentangle® Primer—Volume 1: This is the second book from the founders of Zentangle, Rick Roberts and Maria Thomas. With the ever-growing popularity of the Zentangle method of meditative drawing and the amazing art out there, I sometimes find myself spending more time just looking at all the ideas and new tangles than actually tangling! This book is a wonderful return to what Zentangle is all about. There are no new tangles introduced in it, but there is a wealth of knowledge about the fundamentals of Zentangle and how to take your practice of the method to new levels. Whether you are a beginner or seasoned tangler, this book is a must-have. ($49.95, *www.zentangle.com*)

—**Carole Giagnocavo, Publisher and Certified Zentangle Teacher (CZT)**

The Slate: This nifty device allows you to instantly digitize all your doodles! You simply put a special magnetic ring on any pen or pencil and draw on normal paper on top of the Slate, and the gadget creates a digital version as you draw. It's light and small for easy portability, and has great battery life for travel. It's a bit of an investment, but imagine the flexibility you'll get with a digital doodle! ($159.99, www.iskn.co)

— *Llara Pazdan, Designer*

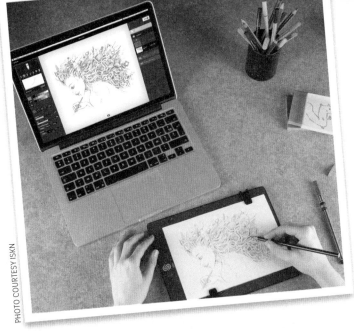

PHOTO COURTESY ISKN

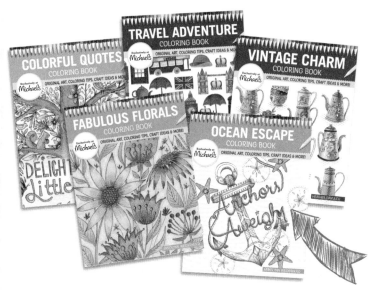

Exclusively at Michaels Coloring Book Series: I love discovering new and amazing coloring book artists, and what makes it even better is when I discover artists with BIG books! These five titles feature art from two authors new to the coloring book scene: Heather Davulcu and Arrolynn Weiderhold. The books were developed exclusively for Michaels stores and feature techniques, craft ideas, and guided coloring pages to get you energized and inspired. But best of all, they're each a whopping 144 pages, so it'll take me a while to run out of art! Look for them at your local Michaels store in August 2016. ($9.99 per book, www.michaels.com)

— *Katie Weeber, Editor*

ArtSnacks: Here at *DO Magazine*, we recently subscribed to ArtSnacks, a subscription that sends us a box of fun art supplies every single month—and I am in love! ArtSnacks will send you four to five high-quality, new and trending tools and trinkets in every box; it's an exciting surprise each month, because you never know what you're going to get. The subscription is a great way to experiment with what's popular in the coloring and craft world. ($20.00 per month, www.artsnacks.co)

— *Kati Erney, Editorial Assistant*

PHOTO COURTESY BEN LOPEZ

Yoga for Your Brain™ 20 Blank Tangle Cards: I just recently started dabbling in the world of Zentangle, and Sandy Steen Bartholomew's blank tangle cards set is a godsend for me. These cards give me a confined space to practice my tangling and, at 3" x 4", are small enough to slip right into my purse for on-the-go patterning. The best part of these cards is that, on the reverse side, there are spaces for me to document every step of the tangle so that I know exactly how to replicate it perfectly the next time. I can practice tricky tangles as well as create my own! ($3.99, www.D-Originals.com)

— *Kati Erney, Editorial Assistant*

The Colorist's Dream Printers

Adapt and print designs at the size you want, on the paper you want, in the quantity you want, and whenever you want with two printers perfect for papercrafts

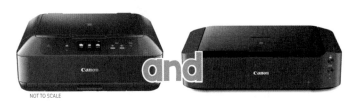

NOT TO SCALE

	PIXMA MG7720 All-in-One Printer	**PIXMA iP8720** Crafting Printer
Best for	Multipurpose use (prints, scans, copies)	Crafting use (prints larger sizes)
Retail Price	$199.99	$299.99
Print Size	up to 8.5" x 14"	up to 13" x 19"
Wireless	Yes (and Cloud-connected)	Yes
Copies/Scans	Yes	No
LCD Display	3.5" touchscreen	No
Paper Feed	2 front cassettes	Rear tray
Inks	6 inks: dye (cyan, magenta, yellow, black, gray) and pigment (black)	

Have you had an amazing coloring page design and a special paper or object (such as a gift bag) that was crying out for color, but you couldn't figure out a way to combine them? Well, there's a printer for that!

Imaging and printing guru Canon has completely revolutionized the world of papercrafts and fine art printing with their line of PIXMA printers. Crafting with stationery materials has never been easier—or more fun! We had the chance to try two models—the **PIXMA MG7720** wireless photo printer and the **PIXMA iP8720** crafting printer—and had a lot of fun discovering their potential for use with coloring designs. Both printers allow you to produce beautiful, high-resolution designs for crafting in custom sizes right in the comfort of your home—the flexibility and freedom is astounding.

PIXMA printers can handily feed archival paper, glossy photo paper, sticker paper, paper gift bags, magnetic sheets, and virtually every other paper product available in the scrapbooking aisle of your local craft store. They will even print on some fabrics and burlaps! You can give your scrapbooks, gift tags, greeting cards, invitations, and other crafts a personal, handmade touch—the sky's the limit! These printers offer convenience—no need for special trips to the store for premade, precut supplies. Since you're in control, you're guaranteed to get the exact custom item you want. And you can make only what you need, rather than having to buy a big pack of supplies that you might never use again.

Now, check out this inspirational gallery featuring projects created with Canon's PIXMA printers, and get coloring and crafting!

Exciting news for the fall! Many Design Originals coloring designs (including some designs featured in this issue of *DO Magazine!*) will be available to print from **Canon Creative Park Premium**, an online service where you can find and print photos, illustrations, paper crafts, and much more, all from internationally recognized photographers and artists. All you need is a Canon printer with Canon genuine ink to access this content. Simply find and print the content from your computer through My Image Garden, directly from the screen of a Cloud-ready PIXMA printer, or from your mobile device with the Canon PRINT app.

Get Coloring!

Here's just a sampling of the coloring crafts we did with the help of the Canon printers. Check out the chandelier on page 42 and the tree on page 46.

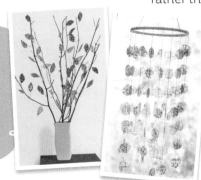

Below: Personalized gift tags are some of the simplest, cutest projects you can make with your at-home printer. Create a sweet, unique party favor or "Thank You" gift by printing your special label with a design you colored and using coordinating embroidery thread or twine to wrap it around a ramekin of delicious, homemade cookies.

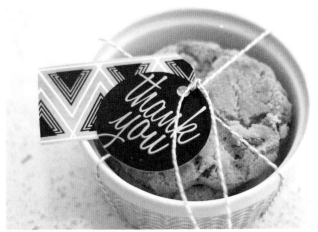

Photo and project by Remodelaholic.com

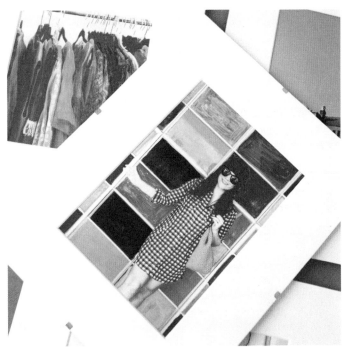

Photo and project by ABeautifulMess.com

Right: With just a handful of supplies, including a tabletop sign, small cup hooks, blank gift tags, and a collection of your favorite colored designs (or photography) printed with your Canon printer, you can create this chic perpetual flip calendar that will always have you looking forward to tomorrow.

All projects featured here were made using PIXMA iP8720 and PIXMA MG7720 printers by Canon. Visit **www.shop.usa.canon.com/crafting** for more info.

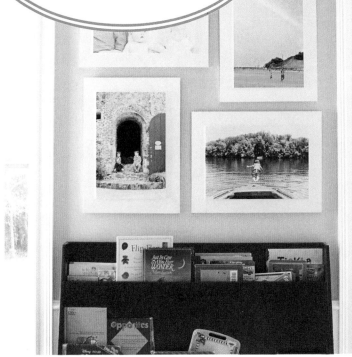

Photo and project by Katie Bower of bowerpowerblog.com

Above: Are you dreaming of gallery walls but hate to spend so much on professional prints and gilded frames? Canon printers are great for producing high-resolution images on a larger scale than normal printer paper! Print your photos or coloring designs at gigantic sizes and mount to pieces of medium density fiberboard (MDF) for a seamless, beautiful gallery.

Left: Channel your inner Andy Warhol to create some awesome pop art snapshots of your life. Print your favorite black and white images onto luster paper and use watercolor washes to add splashes of vibrant, vintage color.

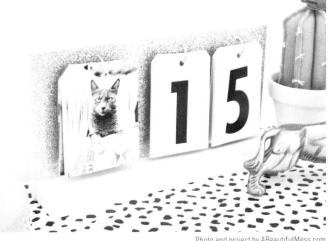

Photo and project by ABeautifulMess.com

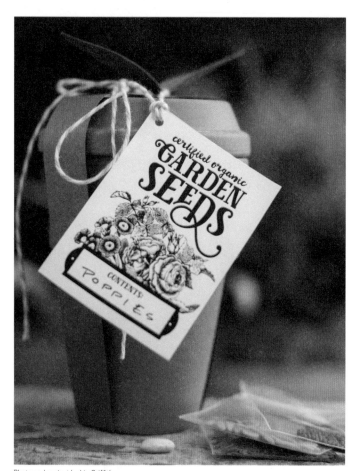

Photo and project by Lia Griffith

Left: Using your Canon printer, creating a series of customized labels and notecards for gifting home and garden supplies is an absolute breeze. It's as easy as photocopying one of your favorite designs (or drawing your own), printing the art onto thick cardstock, and coloring and personalizing for a unique touch.

Photo and project by Jen Carreiro of somethingturquoise.com

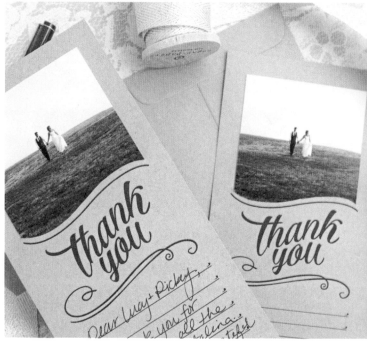

Above: Using nothing but your Canon printer, a paper cutter, some glue dots, and your imagination, you can make beautiful, professional-quality thank-you notes for your family and friends—for any occasion.

Left: Create effortless, affordable reminders and mementos for special events by printing onto magnets! Whether it's saving the date or memorializing a colored quote, printable magnets are the way to go—and your Canon printer prints on them!

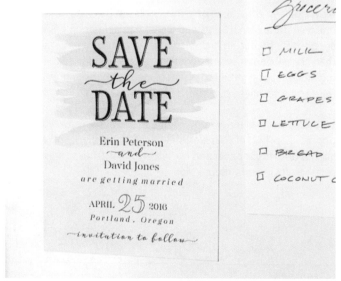

Photo and project by Lia Griffith

Right: Planning a unique event? Show off your creative style by coloring your own table numbers using free printable designs like these from Something Turquoise! Or color a design from your favorite coloring book and cut it to the desired size; then, add a plain or embellished number to the center and frame for a beautiful and completely unique look.

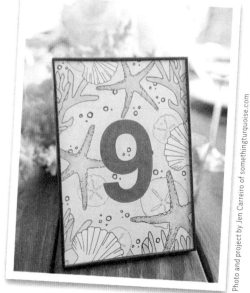

Photo and project by Jen Carreiro of somethingturquoise.com

Right: Take your favorite colored pieces and memories everywhere with you by using your Canon printer to make a lovely little DIY coloring and photo journal. Print photos, stickers, borders, frames, and backgrounds to commemorate a special trip or occasion—all in one place.

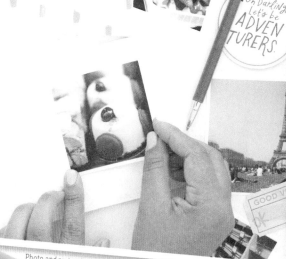

Photo and project by Amber Kemp-Gerstel of damasklove.com

Left: Have you found a black-and-white printable design online that you adore? Download the image and print it onto cards! Color the design any way your heart desires and send to all of your loved ones.

Photo and project by Amber Kemp-Gerstel of damasklove.com

Thanks so much to the contributors who shared their ideas for this article!

Elsie and Laura: A Beautiful Mess, www.abeautifulmess.com

Katie Bower: Bower Power, www.bowerpowerblog.com

Linda Gardner: Craftaholics Anonymous®, craftaholicsanonymous.net

Amber Kemp-Gerstel: Damask Love, www.damasklove.com

Jen Carreiro: Something Turquoise, www.somethingturquoise.com

Cassity Kmetzsch: Remodelaholic, www.remodelaholic.com

Lia Griffith, www.liagriffith.com

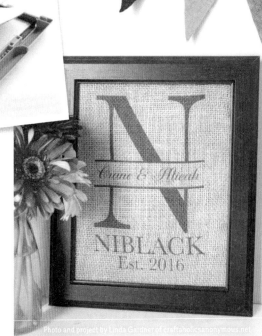

You can even print on fabrics, like this thin burlap! Simply choose a design, add a stabilizer to the back—such as ironing on some freezer paper—and it will feed through your Canon printer just fine. Try framing your finished design as shown here!

Photo and project by Linda Gardner of craftaholicsanonymous.net

Coloring on Location

We've all got our favorite spot in our home where we color, whether it's our kitchen table, the desk in our bedroom, a comfy recliner, or in the grass out back. But it's time to stop limiting yourself to home base. Leave your comfort zone and get out there to color!

Why should I give it a try?

First of all, **inspiration is everywhere!** If you're tired of the boring white walls in your apartment or have already been plenty inspired by your own home's décor, lighting, plants, and whatnot, then a change of scenery is just what you need.

Second of all, **it gets you out of the house!** How many of us somehow end up spending too much free time on our couches, glued to our TVs, cell phones, and computers? When you leave your home, you're free of those tempting distractions. Just getting out into the world energizes us to be more productive and engaged. Here's a pro tip, though: silence your cell phone!

Finally, **artists have been doing it forever!** How many times have you seen someone sketching in a museum or park? Take a leaf from their book. Just because you're not drawing what you see doesn't mean that you can't benefit from new surroundings, too.

Where can I go?

There are lots of great options—you know your area best!—but here are three of our favorites.

- **Coffee shops.** Here you have a table to color on and food and drinks to enjoy. You might even get to know the employees if you make it a regular habit!
- **The park.** Declare a patch of land or a bench all your own for a little while and settle in to color. Whether you want shade or sun, to sit or lie down, a busy thoroughfare or a quiet nook, a park has a perfect place for everyone.
- **The doctor's office.** Turn a dull waiting time into a fun, creative opportunity. When you finally get called, you can tell your doctor how you've just been working on your relaxation skills!

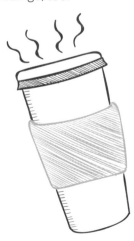

What should I bring?

Depending on where you're going, you might not need all of these things, but you'll surely want some!

- **Travel bag for coloring tools.** If you don't want to take out and put away your tools every time you leave the house to color, pack a handy travel bag with the basics that you'll need, and just grab and go!

- **Clipboard or lap desk.** Not many coloring books are easy to color in without a hard surface to color on, and sometimes you don't want to carry the whole book around. A clipboard or a lap desk makes coloring easy everywhere.

- **Accessories.** You can shut out noise with headphones, shade yourself (and your blinding white page) from the hot sun with a big hat, get comfy for an hour of bench-sitting with a cushion, or sprawl out on the grass with a blanket or beach towel. Wherever you decide to go, bring all the accoutrements you need to make your coloring cozy!

When should I go?

Your schedule is your own, so do what makes sense for you, but here are some suggestions.

- **Off-peak hours or peak hours.** If you want peace and quiet, go when it won't be busy where you're headed; or if you are energized by the bustle, go when it's busy, as long as you can find a spot!

- **Lunch break.** Too many of us eat lunch hunched over at our desks, still working! But you should try focusing on something else—on coloring a gorgeous piece of art—while you have your meal. You'll feel refreshed when you get back to your job.

- **Early morning.** What a great motivator to get up and get moving! Heading out to color early will start your creative juices flowing for the rest of the day.

IN THE MOOD FOR SOMETHING MORE SOCIAL?

Check out the article on coloring clubs on page 4 for ideas on how to color on location with likeminded colorists!

What do I say?

If you're really worried about what people will think of you coloring merrily away in public, first of all—**who cares!** Anyone who judges you clearly hasn't gotten in touch with their own artistic side lately. But some people might be intrigued enough to ask you what you're up to, so here's how to respond. You can start off by just explaining to them **why coloring's great for you**—whether it's relaxing, satisfying, or a way for you to get inspired, your reasons are valid, and you should share them! Here are some ideas: "I can really lose myself in the page—it's super relaxing and refreshing!" · "It's my time for me, with no guilt. I'm not on call for anything." · "It gets my creative juices flowing, and it's much easier to start than a totally blank page." Then, here's an idea: **offer them a piece of art from your book**, notebook, or collection, and a few colored pencils or markers. Even if they don't want to join you in coloring right then and there, you might inspire them to color later. Let them keep the tools! You have plenty, and they'll be struck by your generosity. **Spreading the coloring love is no small thing.**

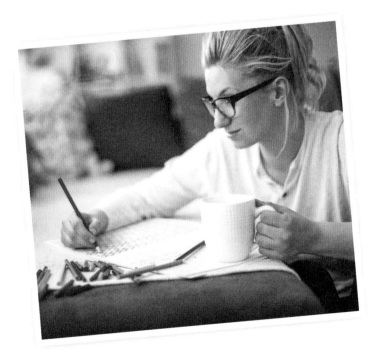

Trending
COLOR PALETTES

Having trouble picking a color palette? Just not feeling inspired? Then let the experts guide you! From time to time we bring in product experts for our articles. This time, we talked to **Julia Benben, Director of Marketing for Chameleon Art Products, North America** (www.chameleonpens.com). She shared with us their six totally new marker color packs for May through September, with each month having its own color palette and focus (and a bonus palette in the last month!). We like Chameleon's pens because they allow you to create stunning effects such as shading, blending, gradations, and highlights, all with just one tool. These alcohol-based markers are refillable and their nibs are replaceable, making them a great investment. They're double-ended, with a brush tip on one end and a fine point nib on the other. Plus, they're compatible with other alcohol-based inks, if you already have a collection. Julia chatted with us about color trends and Chameleon's new marker packs, which provide a great way to get started and color in style.

What is a color trend?

We consider a color to be trending when we see it used in a lot of different sites and mediums around the same time. For instance, we may see a color used on a variety of crafting websites as well as on mainstream websites and in print. If it is a strong trend, it will also be found in other places, such as in makeup, fashion, or home décor.

How do you determine a color is trending?

We keep tabs on popular blogs, Facebook groups, and magazines in the craft and coloring industry to see what artists are using. Pinterest boards are also perfect for this!

What advice can you give readers about looking for color inspiration or spotting color trends?

The web is a virtual visual playground of inspiration, and there are so many great sites that you don't need to go far to find color inspiration! But don't limit your search to your artistic sphere—look in all aspects of life. Colors that are trending will be seen everywhere—in shops, in gardens, on social media, etc.

What about the colors you selected for the new packs makes them fresh and exciting for 2016?

We worked with a lot of different artists from all walks of life—tattoo artists, manga artists, commercial artists, and professional crafters—to find key colors that would complete the current palette we had. We also looked at popular trends. For instance, our new Lagoon color was influenced by the current love of succulent plants. Our new Mellow Yellow color draws upon the pastel trend in makeup and nail polish. We also looked at trends from Pantone, a company that provides a universal language of color, and their "colors of the year"; their official colors of 2016 are reflected in our new shades of Dusty Rose and Cornflower.

What makes these marker packs easy to use?

Color packs that are grouped either by color family/hue or by a theme are very easy to imagine using on a piece of art. But the best part is that we can be much more efficient with what we put in our color packs because our pens can produce multiple color tones with just one pen. In most cases, our packs will have unique colors like a warm red, cool red, and coral red, rather than a light, medium and dark version of a warm red. Because you can adjust the color tone of the ink with our system, you only need one warm red, not three!

May: Floral

You know what they say about April showers! Celebrate the beauty and freshness of spring with the Floral Tones Set, which includes garden-inspired colors. Coloring flowers is currently a hot trend, with Johanna Basford's *Secret Garden* and many more floral-themed coloring books soaring in popularity. Floral tones are also a wonderful everyday palette that can work in fashion, home décor, and more.

June: Nature

The summer sun brings the world to life! This somewhat muted palette features colors that occur prominently in nature and is meant for coloring plants and natural landscapes with its rustic browns and greens.

July: Skin "Comic-Con Special"

Comic book geeks rejoice! There is now a palette ready to bring your comic and manga characters to vibrant life. The Chameleon system gives you the ability to lighten or darken the color of the ink so you can get a much wider range of diverse skin colors and a more realistic custom palette. Don't worry, though—for more fantastic skin colors like blue or green, check out the other trending palettes.

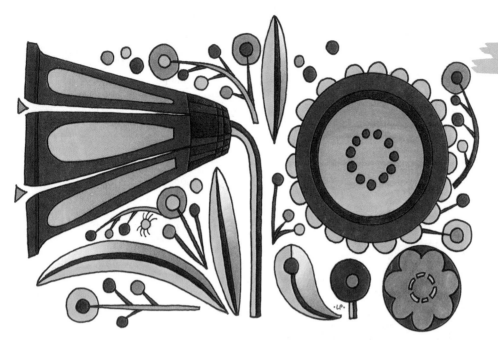

August: Warm

Celebrate the close of summertime with the warmth and fun of hot and spicy colors. There is always a large demand for different reds, oranges, and yellows, so Chameleon expanded their main set to include warmer and cooler versions, offering a complete range and the ability to adjust the tone of these rich, bold, happy shades.

September: Blue (plus Gray)

Get ready to usher in autumn skies with this palette of cool blues. Chameleon wanted to cover a wide variety of blues from robin's egg to indigo to blue-greens and give artists the ability to go up and down the tonal scale of each color. Plus, try the Gray Tones Set—it goes very well with the blues, as you can see in the sample here! Grays are an important resource for artists used on their own and also in combination with other colors. The new pack includes warm, cool, and neutral grays.

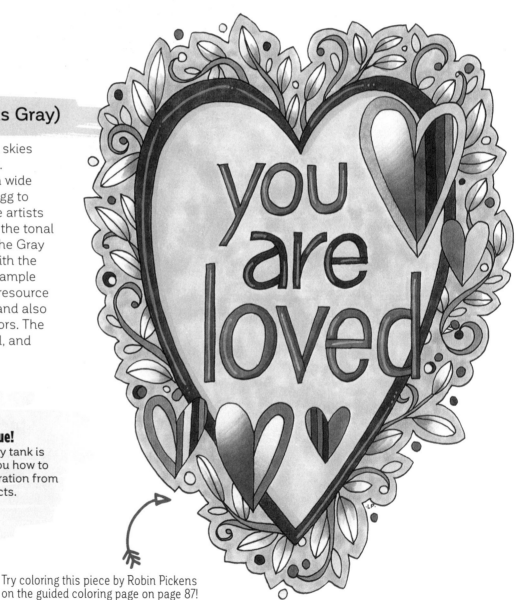

In a Future Issue!
When your creativity tank is empty, we'll teach you how to refuel your color inspiration from everyday objects.

Try coloring this piece by Robin Pickens on the guided coloring page on page 87!

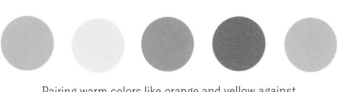

Pairing warm colors like orange and yellow against cool colors like green and blue will allow the colors to stand out against one another.

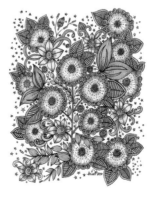

Normality is a paved road:
it's comfortable to walk,
but no flowers grow on it.

—Vincent van Gogh

Skyward Bound

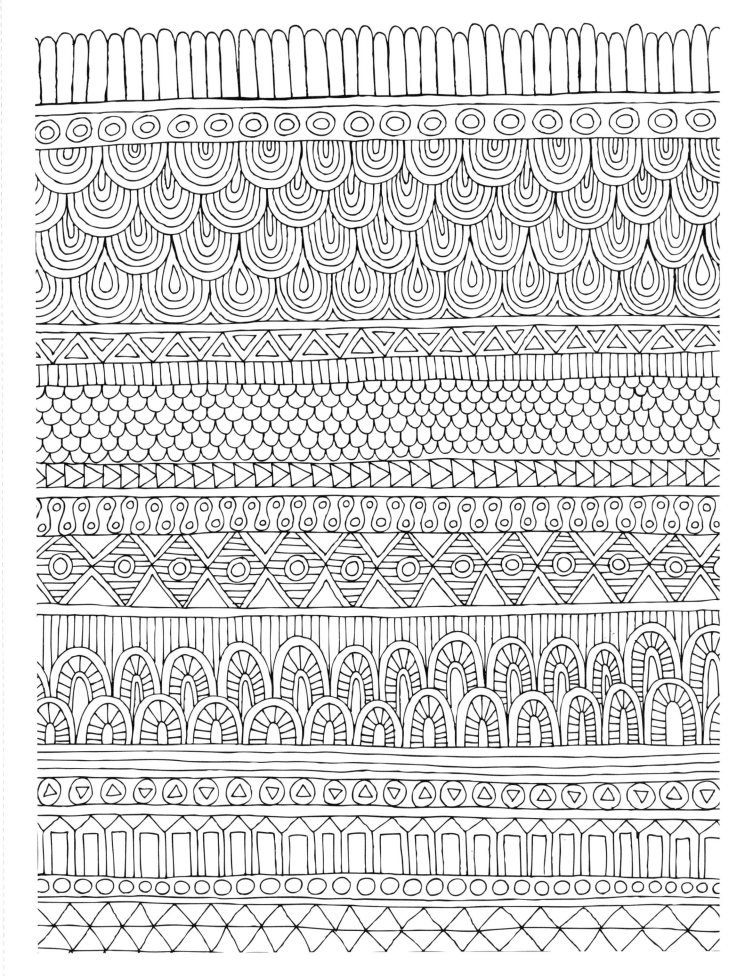

Turn off your mind, relax,
and float downstream.

—The Beatles, *Tomorrow Never Knows*

Hello Angel #1097

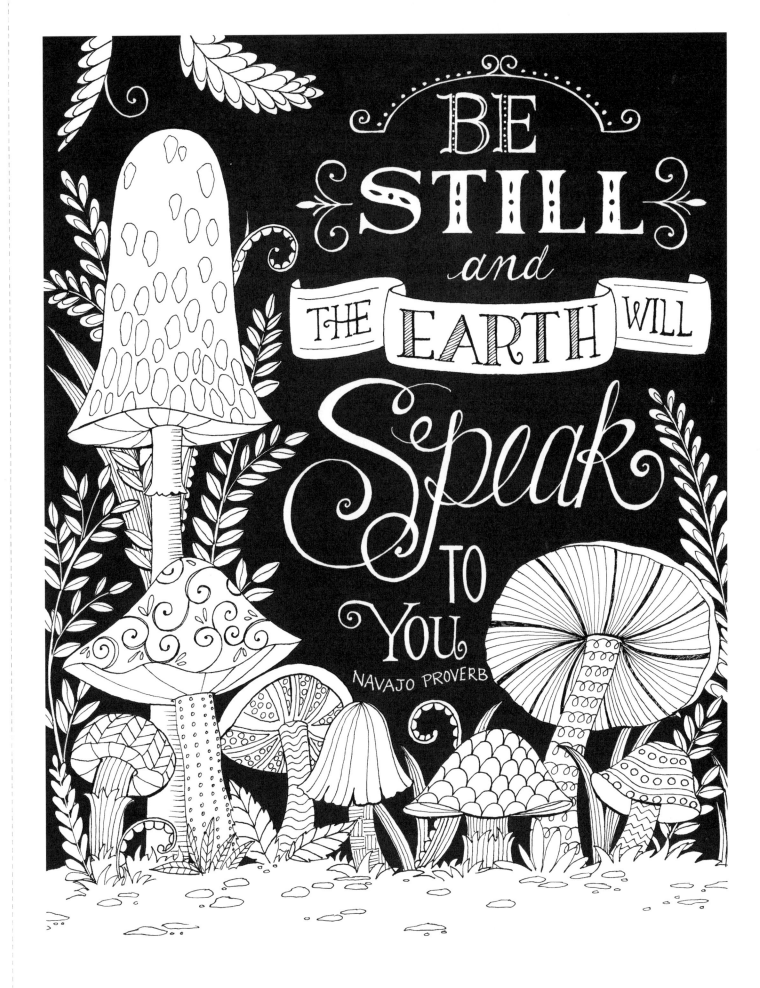

BE STILL and THE EARTH WILL Speak TO YOU

NAVAJO PROVERB

21

The earth has
its music for those
who will listen.

—George Santayana

Listen to the Earth

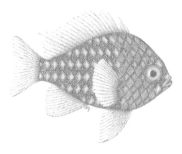

We are tied to the ocean. And when we go back to the sea, whether it is to sail or to watch—we are going back from whence we came.

—John F. Kennedy

DO#1072, Moorish Idol

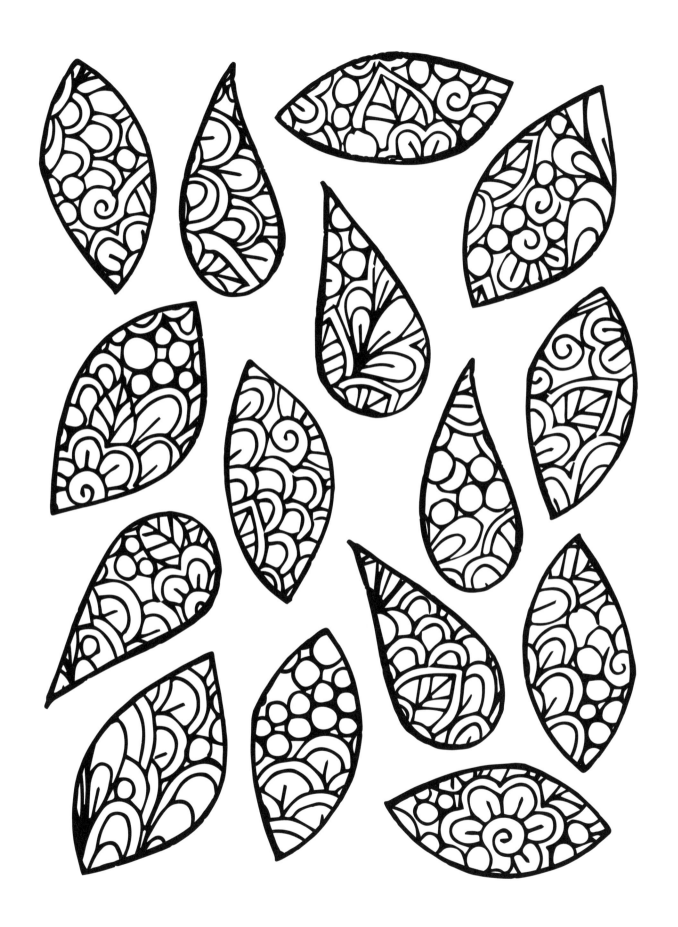

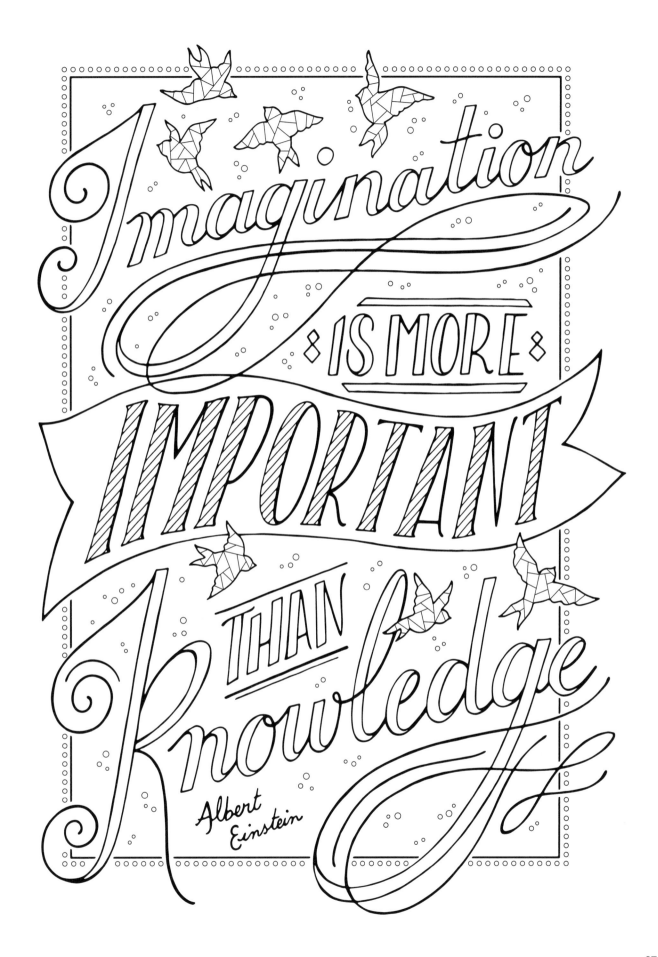

Imagination is more IMPORTANT than Knowledge

Albert Einstein

Laughter is timeless, imagination has no age,
and dreams are forever.

—Walt Disney

Imagination

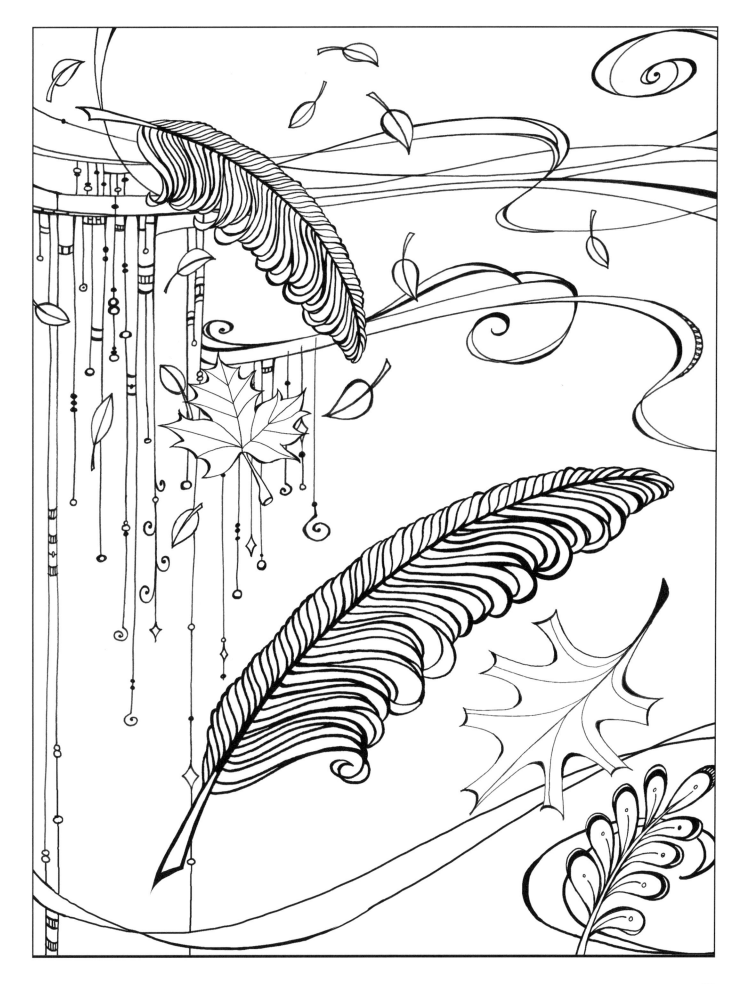

The moment you doubt
whether you can fly, you cease
forever to be able to do it.

—J. M. Barrie, *Peter Pan*

Feathers

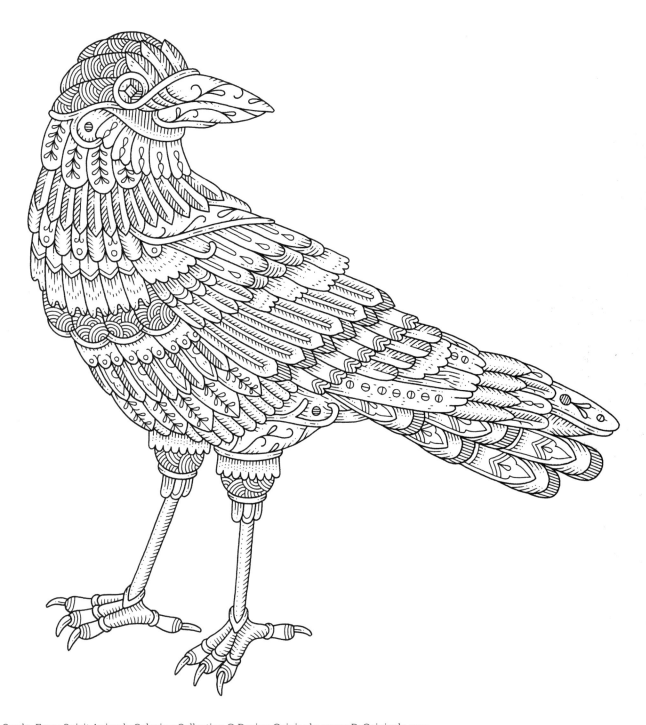

Using shades of green with gray and black creates a dramatic effect.

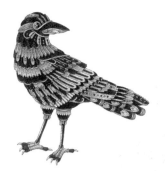

The most beautiful thing we can experience
is the mysterious.

—Albert Einstein

Crow

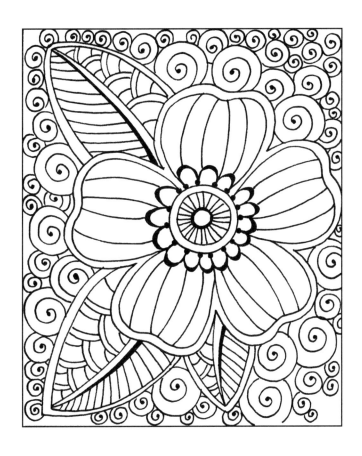
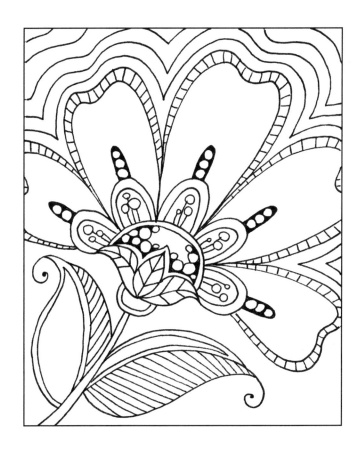
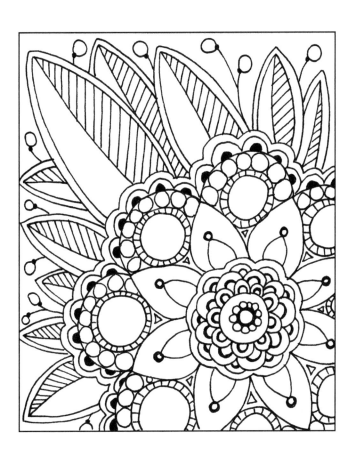
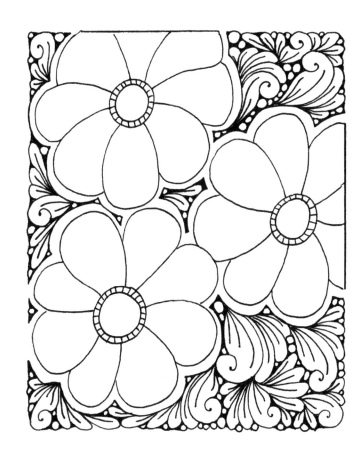

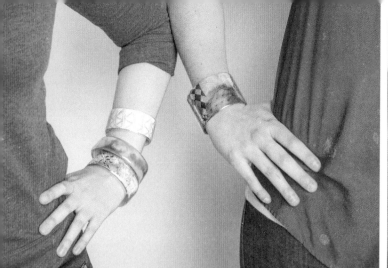

THINK SMALL!
Jewelry :WITH:
COLORING PAGES

We're always told to think big... but what about thinking small? Coloring pages can easily be adapted into delicate pieces of jewelry. For all of these jewelry ideas, you can either reduce a design you've colored to the size you need, or simply cut out a shape from a finished coloring page. Remember to use a photocopy of your colored piece, unless you're okay with cutting up your original! *For these projects, reduce the size of your completed colored artwork as needed to suit your project, either by photocopying it or by scanning and printing it at a reduced size.*

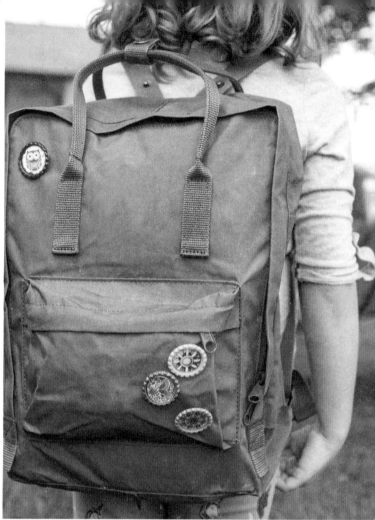

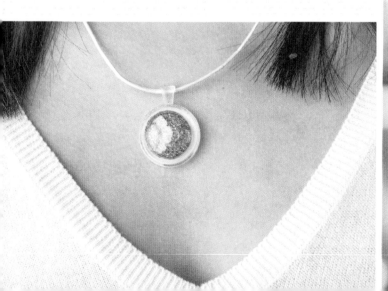

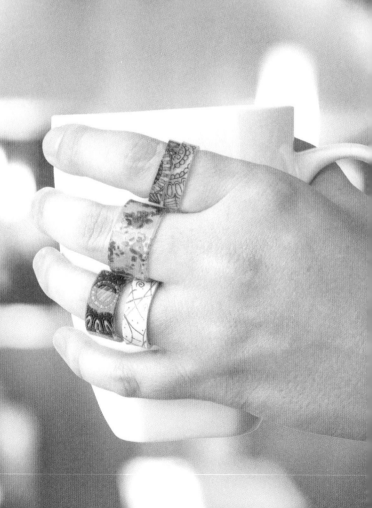

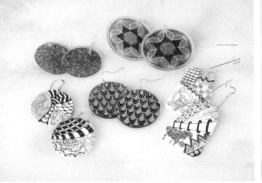
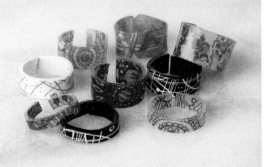
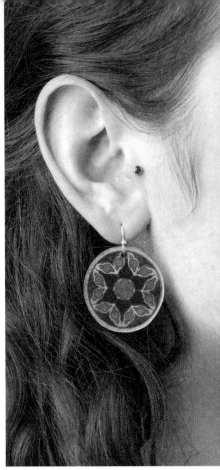

Shrinky Dinks® Jewelry

You can use the magic of Shrinky Dinks paper to make earrings, necklaces, and even rings! Photocopy or print a colored or uncolored pattern onto Shrinky Dinks Frosted Ruff N' Ready or Ink Jet paper at about 3 times the size you would like the finished piece to be. (So, earrings that you want to be 1" in diameter when finished should be printed at 3".) Color the design if it's not already colored. Note that the colors will become darker and more vivid once the paper is heated and shrunk. Cut out your final design, and make a hole with a hole punch if you are making a necklace or earrings. Bake the piece following the manufacturer's instructions. To make rings, use rectangular strips and just wrap the design around a marker immediately after taking it out of the oven—it hardens quickly! Add jump rings, string, or chains to polish off your creations.

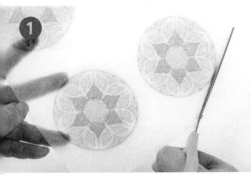

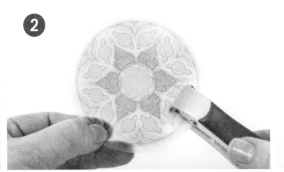

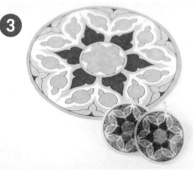

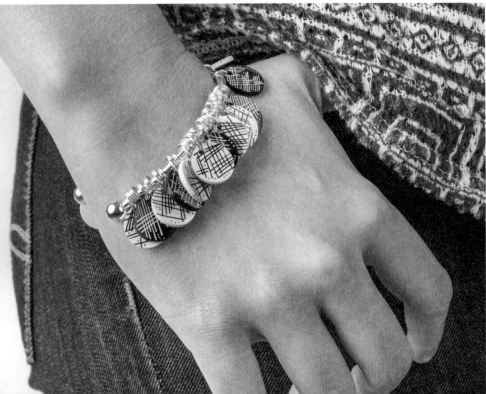

You can also doodle or do Zentangle on Shrinky Dinks! See page 65 for more info on Zentangle.

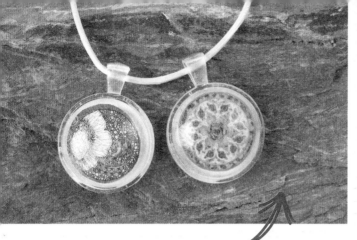

Resin Mold Jewelry

You can find all kinds of cool resin molds online, and a small casting epoxy/resin kit will last you a long time, so don't hesitate to try this technique! Reduce and trim your design to fit your mold. Coat the front, back, and edges of the design lightly with white glue to seal it, allowing it to dry on wax paper. Mix the epoxy according to the manufacturer's instructions and fill the mold halfway. Gently place your artwork into the mold, and then continue to fill until the mold is full. Wait 24–48 hours to cure.

Bottle Cap Accessories

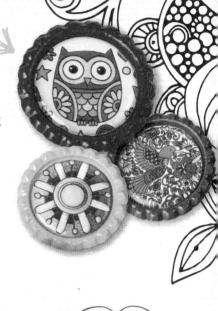

Whether you're recycling used bottle caps or buying bottle cap kits, you can whip up the coolest pins, necklaces, and decorative elements in a matter of minutes. Reduce and trim your colored design into a circle to fit the center of the cap, then glue it to the cap and allow it to dry. If you have a clear protective disk for your cap, add it—but you can also go without, or add a coat of clear decoupage medium over top.

Feel free to embellish your bracelets with charms, puff paint, beads, and more!

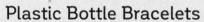

Plastic Bottle Bracelets

This isn't just a style for kids! Choose a plastic bottle whose circumference in the center is big enough to go around your wrist comfortably (1-liter bottles work for most adults, while standard 12- to 16-ounce bottles work for smaller wrists). Cut a circular "bangle" out of the center of the bottle as wide as you want the bracelet to be—it helps to start by making a horizontal slit with a sharp utility or craft knife before bringing in the scissors. Now remove the label from the bangle (it's easier at this stage). Turn an iron to its highest setting, and, once it's heated, gently but firmly press one edge of the bangle to the iron for about 7 seconds (it won't hurt the iron). The plastic will curl inward slightly, making the edge soft instead of scratchy. Do the same on the other side of the bangle. Then cut a coloring page strip to fit inside the bangle, and—*voilà!*—your creation is complete!

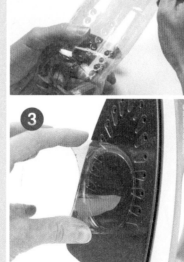

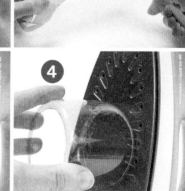

Watercolors 101

LEARN ALL THE BASIC TOOLS, TECHNIQUES, AND TIPS FOR THIS GORGEOUS COLORING MEDIUM

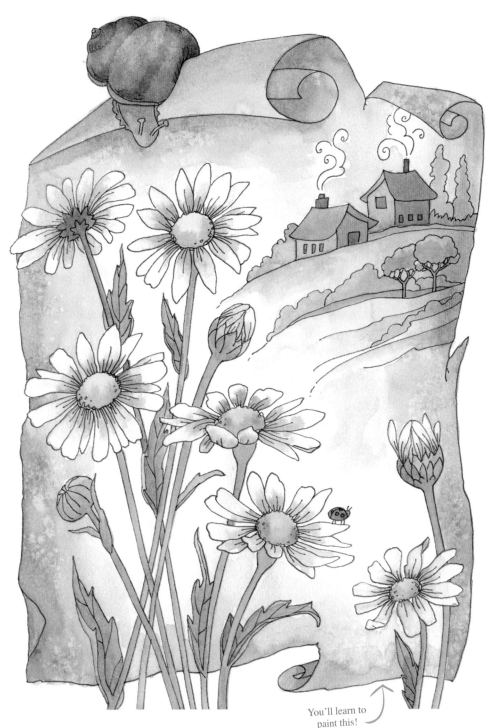

You'll learn to paint this!

BY MARIE BROWNING

Many of you colorists out there think that watercolors are too difficult to work with, but after you read this article, you'll realize you can definitely master this technique and make wonderful colorings using watercolor's transparent layers and delicate gradients.

About Watercolors

Watercolors are water-soluble paints that remain workable with a small amount of water even after they have dried. Most watercolors are transparent; this allows the white paper or underpainting to show through. You will need to decide if you want student-grade or artist-grade watercolors. Student-grade paints are fine for a beginner, especially as you first learn and experiment. However, I think buying the best you can afford is always a good idea, as there is a big quality difference between a child's palette of watercolors and artist-grade watercolors.

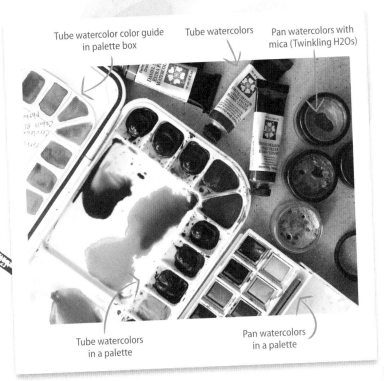

Tube watercolor color guide in palette box

Tube watercolors

Pan watercolors with mica (Twinkling H2Os)

Tube watercolors in a palette

Pan watercolors in a palette

Pan: I recommend these, as they are compact, easy to store, and come with a variety of pre-selected colors. There are student- and artist-quality options to suit any budget. The small, covered palettes are great for on-the-go painting. Just spritz the dry colors with clean water before you start to paint. You can also find pan watercolors mixed with finely ground mica for a sparkly effect. *(Top brands: Windsor & Newton, Sennelier, Rembrandt, Cotman, Loew-Cornell, Daler-Rowney.)* **Tube:** Watercolors in tubes have a thicker, paste-like consistency and are designed to use fresh from the tube. You just squeeze out a small amount onto a palette. Tubes are a bit bulky but are very easy to find at fine art stores. *(Top brands: same as pan brands.)* **Liquid:** Liquid watercolors are like bottled inks and have very strong, brilliant colors. They're good for large paintings and effects where you don't want to dilute the colors. They are not as portable, are cumbersome to store, and are a bit messy to use. *(Top brands: Dr Ph Martins, Sax.)*

Watercolor Tools

Brushes: You only need three or four good brushes, if you take care of them. The best watercolor brushes are made with natural fibers such as squirrel or sable, but these are expensive. Soft, synthetic brushes work fine. Make sure you are buying brushes that are designed for watercolors. A good, basic set of sizes includes a #4 round (general painting), #8 round (large areas, background washes), and #1 round (fine details).

Water container: Use a large container to keep your water clean. Two containers are even better: one for cleaning the brush and the other to keep clear and clean.

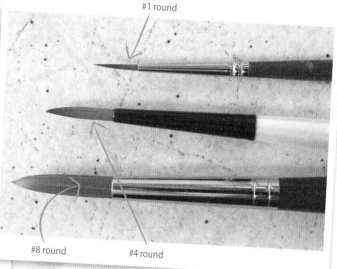

#1 round

#8 round

#4 round

Mister: For spraying a fine mist onto your paints at the beginning of your painting session.

Magic eraser and sand eraser: For removing mistakes (see page 40).

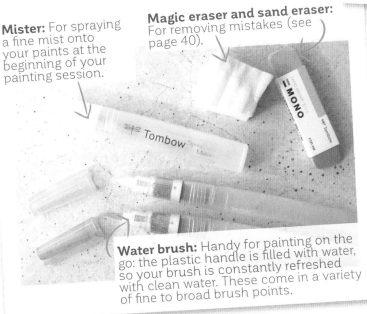

Water brush: Handy for painting on the go: the plastic handle is filled with water, so your brush is constantly refreshed with clean water. These come in a variety of fine to broad brush points.

Palette: These are plastic trays with small depressions (or wells) for mixing colors.

Paper towels or a natural sea sponge: Useful for cleanup and diluting paint on the brush.

Scrap paper: Essential for testing colors.

Low-tack masking tape or painter's tape: For adding masks/stencils and stabilizing your paper.

Color wheel: Handy for mixing colors and planning color palettes.

Working with Watercolors

I'm going to cover four basic approaches for applying watercolors to your art. You can mix and match them within a single piece of art like I have done, or use just one all over a single piece of art—whatever you want! As you get started, keep your colors clear by not mixing too many different colors together. It's easy for beginners to quickly get lots of muddy colors. And remember this basic tenet of watercolors: with more water on the brush, the paint is more translucent; with less water, the paint is more vibrant and less translucent.

Stems: Wet-on-Dry Method
For this method, just get your color on the brush, test it on your scrap paper, and paint the entire area you want to color. The stems of these daisies are painted using three different greens to create visual interest—bright lime green, olive green, and medium green.

Flowers: Wet-on-Wet Method
For this method, you want to embrace the bleed and let the colors blend together. You will get different blends depending on how much water you use.

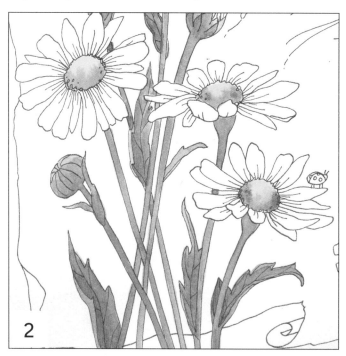

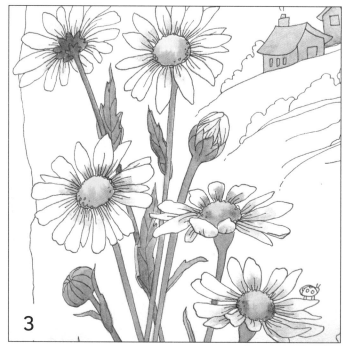

Paint the daisy centers first with a light yellow, and, while the yellow is still damp, add orange to the bottom of each center. Just dab the orange paint on with a light touch and let it blend on its own—if you play with it too much, the colors will end up melding together into a single light-orange color. Wait until the paint is dry to evaluate the finished effect.

These flower petals are also done with the wet-on-wet method, but instead of one color after another, first you "color" the petal with clean water, and then you add blue lightly at the bottom of the petal. This creates a nice light blue fade-out.

Landscape: Glaze Method

This wet-on-dry technique is made up of thin layers of translucent colors.

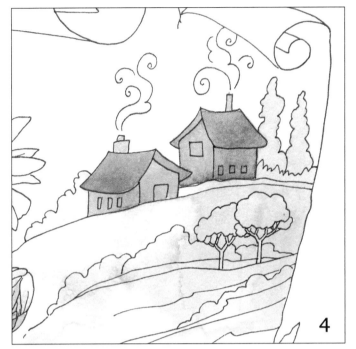

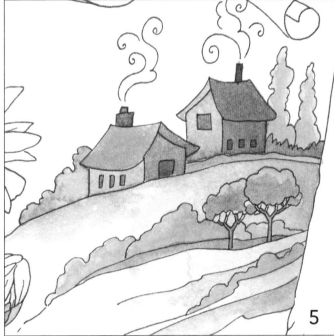

Start the little village with a light green over all the trees and bushes and a light brown over the houses. Let this layer dry completely, and then add additional color layers on top.

Background: Overall Wash Method

When doing an overall area wash, make sure you mix enough color for the entire surface; it's always better to mix too much rather than run out! Here, I decided to add a background color to the parchment, with darker edges and a white highlight in the middle. Use a large #8 round brush and apply the color to the edges. Then clean off the brush, wet it with clean water, and lightly brush from the colored area inwards to extend the color and have it fade to clear. I also added salt to this color (see page 41) for a vintage feel.

Do not overwork the paint while using this method, as you might scrub away the underpainting! You can keep adding layers, letting each one thoroughly dry, until you are happy with the color and intensity.

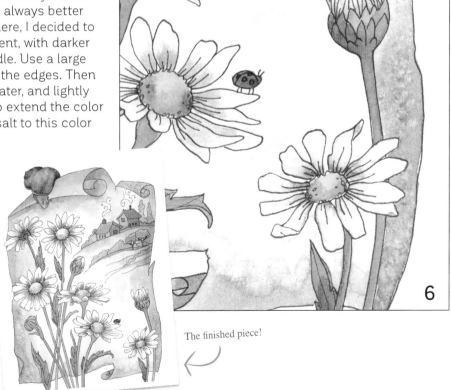

The finished piece!

To see step-by-step how the wet-on-wet technique is done, visit our website! www.domagazines.com

10 Essential Tips

1. Spritz pan (or dried tube) watercolors with a fine mist of water at the start of each painting session to get them ready to use.

2. Always test your colors on a scrap piece of paper.

3. Good overhead lighting is very important—it allows you to see the wet or damp areas on your painting.

4. Too much water on your brush? Simply touch it to a paper towel or clean sponge before coloring to absorb excess moisture.

5. To keep paintings from warping, use an adhesive (such as masking tape or painter's tape) to adhere them down to a base and prevent any paper distortions.

6. Plan your painting so you know where you want to have the white highlights—and use a resist (see page 41) to keep them white if needed.

7. Take good care of your brushes. Clean them with running water and a little soap. Dry them laying flat on a towel.

8. When your water turns brown, it's time to dump it and get clean water.

9. Don't over-mix your colors. Start with just mixing two colors at the beginning, and then move to mixing more complex colors as you get familiar with the paints. Learn the color wheel.

10. Have no fear and just have fun!

Fixing Mistakes

Many say you cannot fix a mistake when working with watercolors, but here are a few hints you can use to minimize and correct slip-ups.

- **Paint with a paper towel or damp sponge in your free hand.** If you apply too much water, simply soak it up right away.
- **If you go over a line with the paint,** immediately blot it with a paper towel to remove the color. If you can still see the color, add a little clean water to the paper and blot it again. Let it dry a bit before applying more paint.
- **If you have a fingerprint smudge or a drop of errant paint,** you can use a sand eraser to remove it. Use only on dry paint and when you are completely finished, because the eraser will change the absorbency of the paper and the way it accepts paint.
- **The Mr. Clean Magic Eraser (a home cleaning tool!) can also remove paint.** Make sure the sponge is just damp, not wet; remove color by gently erasing. This works well if you have made an element too dark compared to the rest of your composition. It will also take the printed design off, so use sparingly. Let the area dry completely before adding more color.

> All the pieces you see in this article are in this issue for you to color!
> See the inserts after page 16 and 32.
> Note: The cardstock will accept a light to medium amount of water, not a very heavy amount of water, so if you want to go to town on the pieces, you should photocopy the art onto thicker watercolor paper.

Special Effects

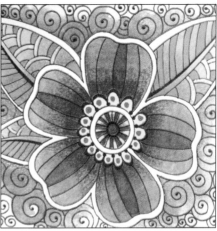

Mixed Media

Traditional colored pencils and gel pens can be used with great success on top of dried watercolors. The first image shows the watercolor base. The blue background was done with a wet-on-wet method, and the flower petals with layered glazes. The second image shows shading done with a red pencil in the petals and a green pencil in the leaves. Details, dots in the center, and coloring of the details in the leaves were all done with gel pens. I also used a clear glitter pen around the flower and then a paintbrush and water to blend the sparkle in.

Salt

This favorite watercolor technique adds a wonderful mottled texture to the color. Apply a wash of color, and, while it's still damp, sprinkle on some salt—anything from table salt to coarse sea salt will work. Put the piece aside without touching it until dry. Different salts and papers give different results, so the effect takes on a different look every time. When the piece is dry, wipe the salt away to reveal the effect. This technique works best on large, solid, colored areas—using it on drawn details may look too busy.

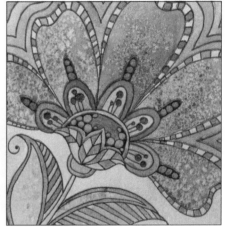

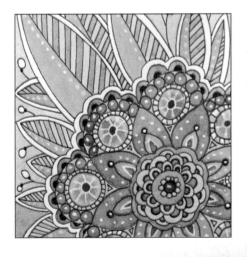

Glue Pen Resist

You can use a glue pen to mask small, fine areas of color in your paintings. Before starting to color, draw with the glue pen where you want it to stay white. Do your watercolors, and as the paint dries, you will see the white appear. Some colors work better than others; darker hues provide the best contrast. Dots and lines work better than coloring in large sections with the glue pen. The glue is clear and does not need to be removed when dry. For large resist areas, you can find masking products in fine art stores that can be painted on and then removed when dry.

Stencils and Mr. Clean Magic Eraser

This technique is done on top of dried paint in a larger, single-colored area. You just need a stencil (small, fine designs work best) and a magic eraser (the type used for cleaning). Dip the magic eraser into clean water and wring the excess water out. It needs to be damp, not wet. Place the stencil over the dried paint and erase through the stencil. You may need to mask off nearby areas to prevent over-erasing. Remove the stencil and let the piece dry. Use a clear glitter gel pen to color in the erased areas for an extra sparkly image.

Airy ART CHANDELIER

BY KATI ERNEY

There are always new, innovative, and beyond creative ways to show off the designs that you've spent so much time and effort coloring. In *DO Magazine*, we love to show you projects that will inspire you to think outside of the box when it comes to exhibiting your work—and this colorful chandelier does just that! With a few simple supplies and a free afternoon, you can create this adorable fixture for any room in your home. Hang it near a window to make the most of its effects!

Pattern on page 19.

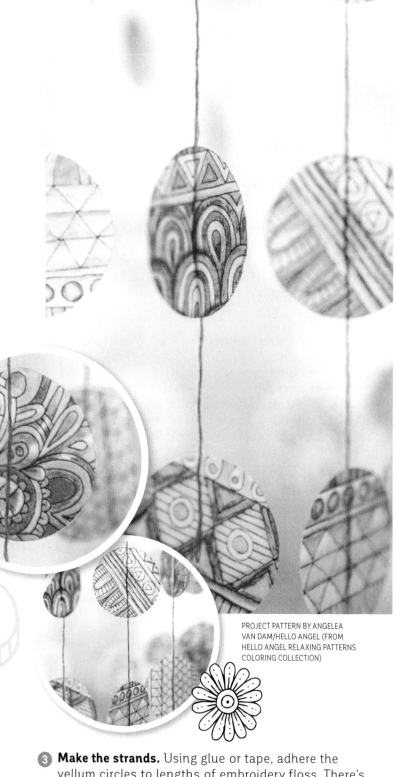

PROJECT PATTERN BY ANGELEA VAN DAM/HELLO ANGEL (FROM HELLO ANGEL RELAXING PATTERNS COLORING COLLECTION)

Materials

- Finished coloring page(s)
- Semitransparent vellum paper
- Circle paper cutter
- Embroidery floss
- Embroidery hoop
- Glue or tape

1 Scan and print your design. Scan your finished coloring page(s) and print multiple copies onto sheets of semitransparent vellum paper. Most home printers can print on vellum.

2 Cut out the circles. Use a circle paper cutter to punch out numerous vellum circles. You'll need quite a few—the chandelier shown here used nearly one hundred 1" circles!

3 Make the strands. Using glue or tape, adhere the vellum circles to lengths of embroidery floss. There's no need to double them up, as the transparent vellum shows the color on both sides, but you can if you prefer.

4 Assemble the chandelier. Tie or glue each strand to the embroidery hoop in evenly spaced intervals.

You can print easily on vellum using one of Canon's PIXMA printers—see page 8 for more info.

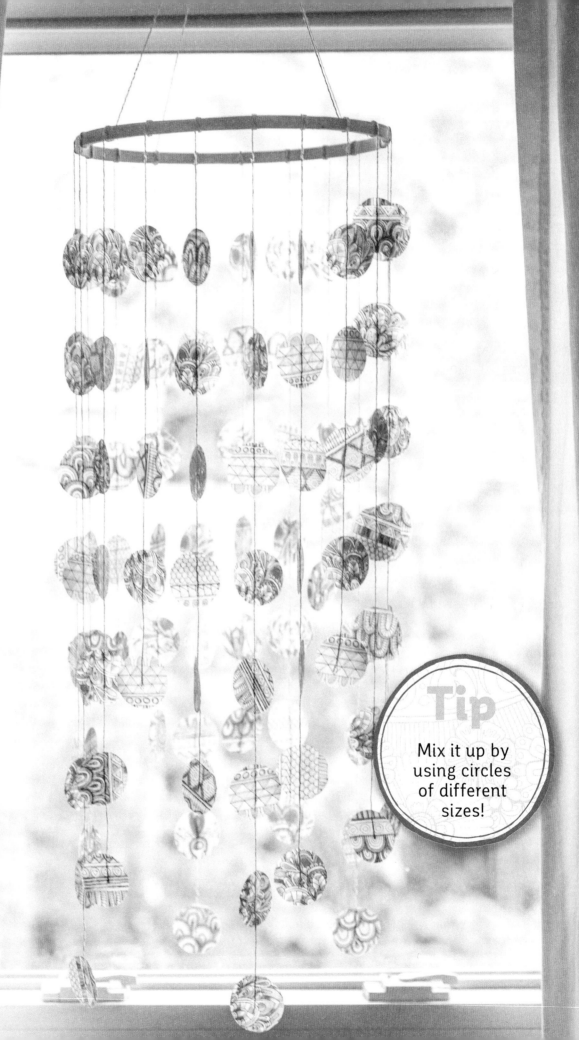

Tip

Mix it up by using circles of different sizes!

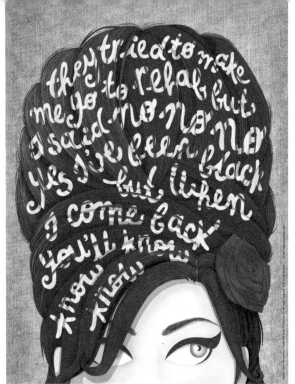

"REHAB" by Amy Winehouse.

DRAW ME A SONG

Fusion of Music and Visual Art

IF you're a fan of music, art, or Etsy.com, you might have come across work by designer and illustrator Nour Tohmé and not even realized it! This artist has found an amazing way to blend unique images with song lyrics that is sure to inspire your creative side. Based in Paris, Nour works as an independent freelancer, but when she is not working for clients, she is running her online shop, Draw Me a Song, which she describes as "an experimental project that explores the fusion between music and visual art."

The Draw Me a Song project started practically by accident when Nour created an illustration featuring lyrics from John Lennon's "Imagine." She uploaded the image to her page on www.DeviantArt.com and started to see a response when the website featured the piece on its homepage.

> " The response to the art has been so positive and truly reflects how much **POPULAR MUSIC UNIFIES PEOPLE** from different backgrounds and cultures. "

"People started commenting on it, sharing it, and asking to buy it as a print. Many also suggested that I make different song lyrics using the same concept, which I started doing," Nour says.

The timing couldn't have been better. Nour, in pursuing a master's degree, needed to create a project that could be turned into a profitable business. Inspired by the response to her "Imagine" art, Nour developed a conceptual business plan and a website, and then launched it as a real business in 2014 after winning financial backing through a competition for creative entrepreneurs. "I think people can relate to the project because they can see their own musical tastes expressed in a physical form," Nour says.

Nour's art has the ability to induce strong feelings, perhaps because Nour is very intentional about what she chooses to illustrate. She focuses on songs that are important to the history of popular music or were written/sung by iconic artists. Then, she strives to create equally powerful art.

Nour explains, "Each piece has a distinct text/image relationship. Sometimes the art is directly inspired by the meaning of the lyrics, like in 'Girls Just Want to Have Fun.' Sometimes the art evokes the artist, like in 'Rehab'; the era, like in 'It Was Acceptable in the 80's'; or the style of the song, like in 'No Woman No Cry,' without necessarily having a direct relationship with the lyrics. And sometimes the art evokes an entirely different concept that is then juxtaposed with the lyrics to produce a new meaning, like in 'We Found Love.'"

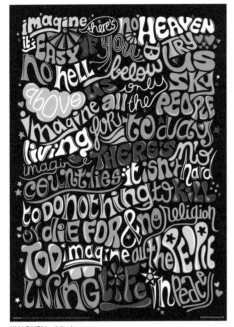

"IMAGINE" by John Lennon.

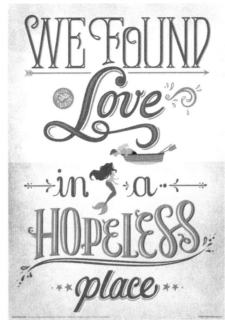

"WE FOUND LOVE" by Rihanna (Calvin Harris).

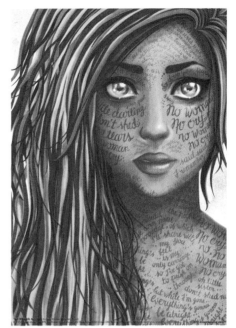

"NO WOMAN, NO CRY" by Bob Marley (Vincent Ford).

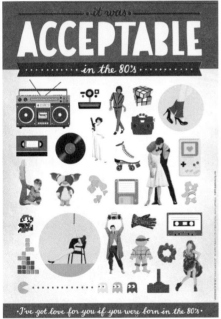

"ACCEPTABLE IN THE 80'S" by Calvin Harris.

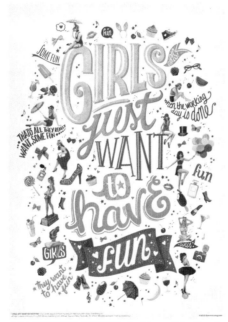

"GIRLS JUST WANT TO HAVE FUN" by Cyndi Lauper (Robert Hazard).

Check out Nour's upcoming coloring book, *Color Me a Quote*, available September 2016.

All of Nour's Draw Me a Song images feature lyrics, but she believes any art that incorporates quotes, poems, or other text can be given a new dimension. Placing text and art together allows for myriad interpretations to create new meanings and ideas.

Nour's art seems like a perfect fit for the adult coloring trend, and she is in the process of developing a coloring book with the Design Originals team. She describes the trend as "a way for busy people in high-stress environments to perhaps release some of their tension. In addition to being therapeutic and calming, it provides people with a creative outlet outside of their work, which can have really positive effects on their confidence and mood."

Nour has truly found a way to embrace her creative passion and turn it into a viable business, and she believes there is room in everyone's life for a bit of creativity. "You can live creatively by embracing your curiosity and exploring activities you love, without necessarily expecting anything in return, such as money or a career," she says.

To learn more about Nour and her work, visit *www.nourtohme.com*. You can also find Draw Me a Song on Facebook, Twitter, and Pinterest.

Check out an inspiring Einstein quote by Nour to color on page 27.

LEAF-BY-LEAF
Coloring Tree

Create a unique statement piece to display proudly in your home or office. This coloring tree is a great way to practice your coloring techniques and use color theory to make a beautiful and unique décor item. You can make different leaves in complementary colors, or make all the leaves monochromatic in dark and light shades of the same color, or anything you choose. And the small size of each leaf makes it a satisfying project to work on a little at a time.

WHAT YOU'LL NEED

Colored leaves. The leaf template is on page 25. You can color the leaves directly on the page and make high-quality photocopies, or you can make photocopies of the black and white template and color lots of leaves however you want. Important! In order to make your leaves two sided, you will need to make sure you use a mirror setting on the copier, or your scanning program, to make a mirror image of half of your leaves. Because the leaves are not all symmetrical, if you skip this step, some of your leaves will not line up back to back!

Branches (real or artificial). You can gather thin sticks and branches from your own yard or purchase artificial ones from a store. Choose branches that aren't too thick and whose bark isn't in bad shape. If you're worried about bugs, check your branches thoroughly, and then use a spray shellac to seal them.

Floral wire or jewelry wire. You will be sandwiching wire between the halves of each leaf and then using it to attach your leaves to your tree. We recommend choosing a wire that blends in nicely with your branches. You will need 4-5" of wire or more for each leaf, depending on how far away you want your leaves to stick out from the branches.

White glue or other adhesive. Use whatever glue you have on hand, as long as it has a strong hold and doesn't cause your coloring to bleed. If you can, try repositionable adhesive—lining up the leaf halves perfectly can be tricky.

A decorative vase. Choose something as simple as a mason jar or as elegant as a Tiffany vase. It's your tree, so use what you like best!

Try making this project using one of Canon's PIXMA printers—see page 8 for more info.

TURN THE PAGE FOR AN AMAZING BONUS IDEA!

Tip

If you want all of your leaves to be consistent and uniform in pattern and color, or you want to whip this project up quickly, we recommend coloring the leaf page and making multiple copies of it. And don't forget to make a mirrored color version for the leaf backs!

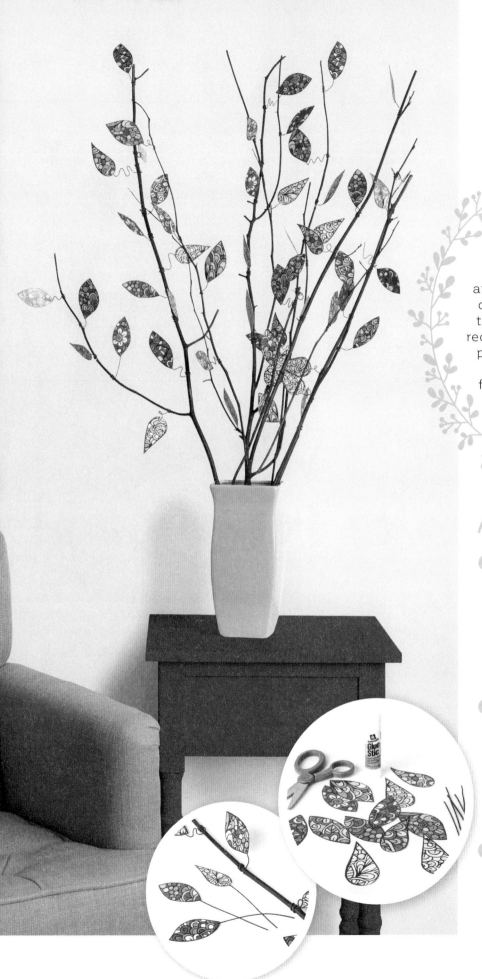

ASSEMBLY

1. **Set up the branches.** Arrange your branches in your container until you are happy with their appearance. If you are having trouble getting them to stay in place, put a piece of floral foam in the bottom of your container and stick your branches firmly into this.

2. **Create each leaf.** Cut out all of your colored leaves and match them up into pairs. Apply glue to one of each pair and then press them together, sandwiching a 4–5" piece of floral wire between them, with most of the wire sticking out from the base of the leaf.

3. **Attach the leaves.** Use the wire tail to twist each completed leaf securely in place on a branch, making sure there are no sharp wire ends sticking out. Spread the leaves out to cover the tree evenly.

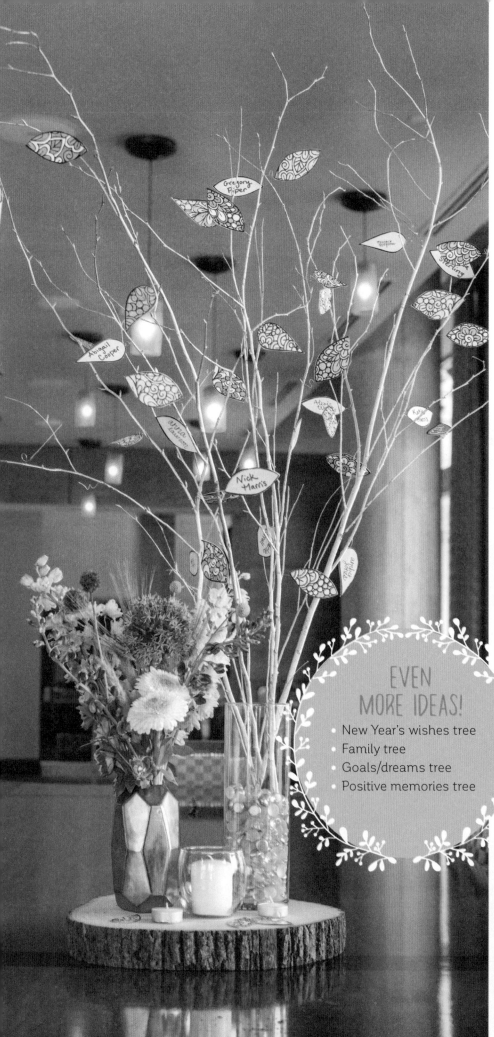

WANT TO CREATE SOMETHING EVEN MORE SPECIAL?

Use a coloring tree as an alternative to a traditional wedding guestbook. Partially decorate the tree with colored leaves so the guests get the idea, then put out leaves and pens for them to write well wishes to the bride and groom. The guests can attach the leaves when they're done, so by the end of the wedding day, a tree of heartfelt thoughts and love will have fully bloomed! It's a one-of-a-kind wedding day remembrance piece that the couple can cherish for years to come.

EVEN MORE IDEAS!

- New Year's wishes tree
- Family tree
- Goals/dreams tree
- Positive memories tree

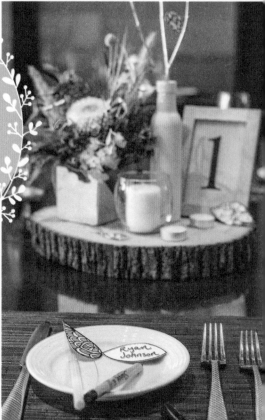

Check out this jumbo design!

Here's a great coloring option for you: a piece that's larger than the standard page size! Just remove each of the two center pages here (pages 50 and 51) and assemble them edge-to-edge to make a single larger coloring piece that will really make an impact!



Raise your words, not your voice. It is rain
that grows flowers, not thunder.

—Rumi

Corinth

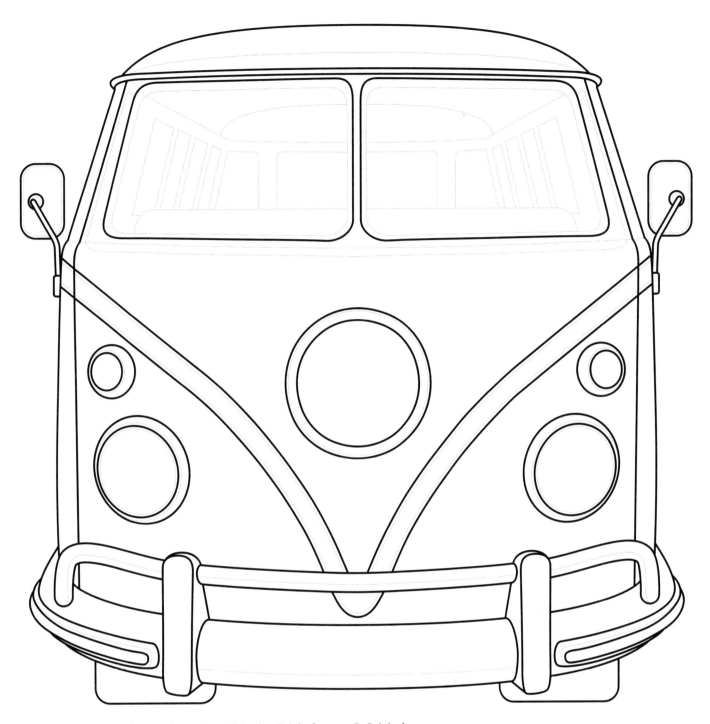

Get creative by adding patterning, like the flowers, hearts, and peace signs that give this van a groovy vibe.

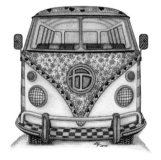

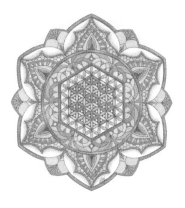

In a gentle way, you can shake the world.

—Mahatma Gandhi

DO#1157, Volkswagen Bus

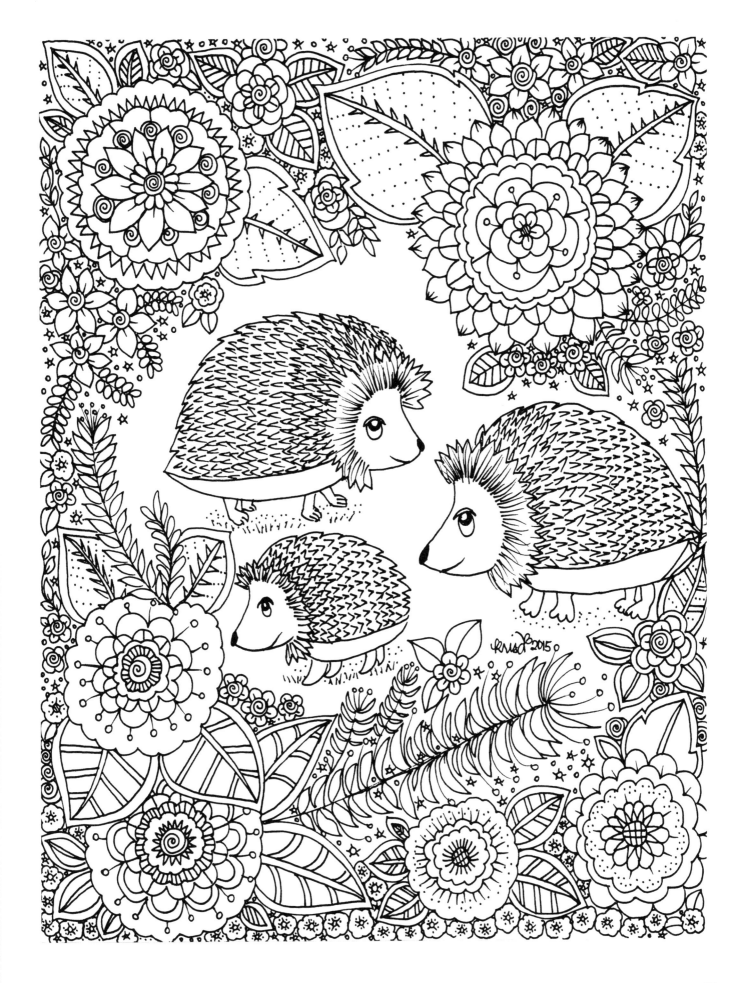

Don't hurry, don't worry. And be sure
to smell the flowers along the way.

—Walter Hagen

Hedgehog Paradise

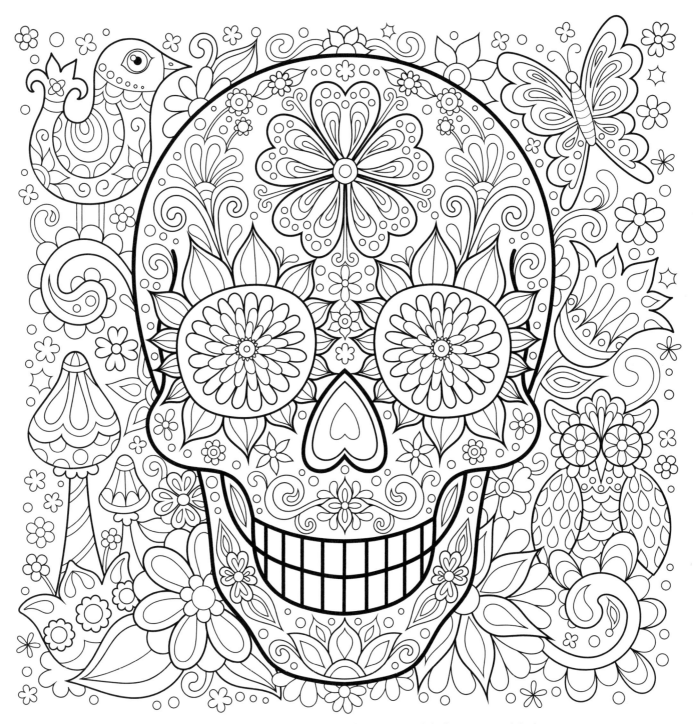

Complementary colors like purple and yellow,
pink and green, and blue and orange will stand out against
one another for bold contrast.

Life is too deep for words, so don't try
to describe it, just live it.

—C. S. Lewis

Life All Around

Autumn is a second spring
when every leaf is a flower.

—Albert Camus

Hello Angel #1227

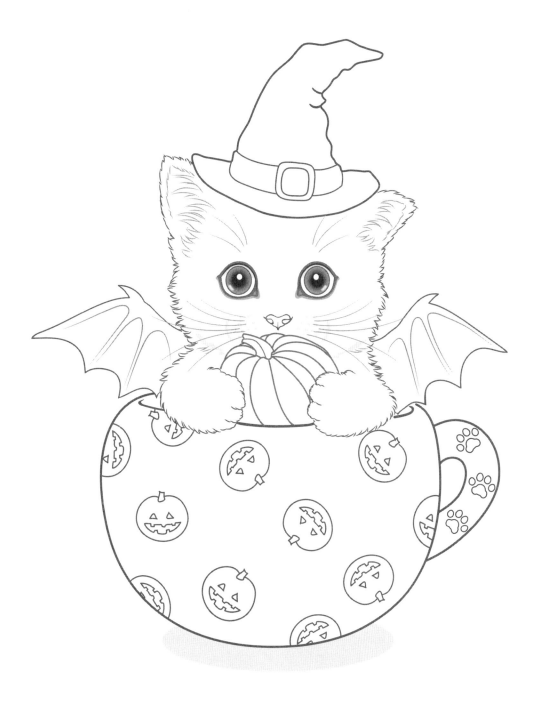

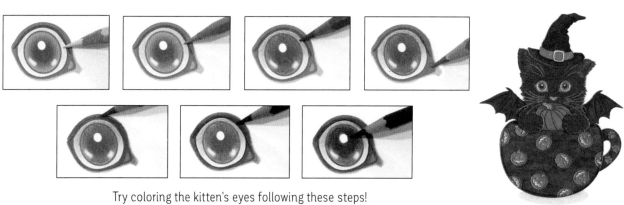

Try coloring the kitten's eyes following these steps!

What greater gift than
the love of a cat?

—Charles Dickens

Boo Kitty

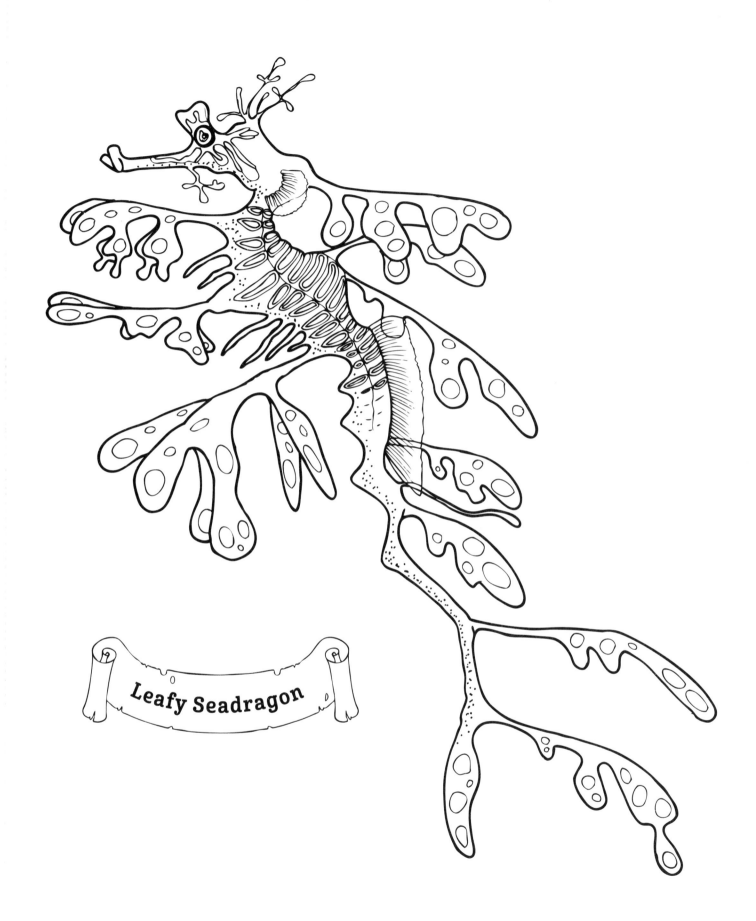

Leafy Seadragon

The ocean stirs the heart, inspires the imagination, and brings eternal joy to the soul.

—Wyland

Leafy Seadragon

DON'T MISS A SINGLE ISSUE!
Subscribe Today and Save 30%!

color
tangle
craft
doodle

Oodles of Zentangle Pumpkins

What is one of the first things you think of when someone says "autumn"? Personally, we think of pumpkins! What better way to get your craft on and decorate your home this fall than by drawing Zentangle designs (or your own freehand doodles) on pumpkins? Here you will find a riot of ways to gussy up your gourds with hand-drawn elements that will be sure to turn heads, courtesy of Zentangle artists and pumpkin queens Lynn Taro and Galen Hale. (Check out these and more amazing pumpkins at Lynn's Etsy shop, Lazytea, and Galen's Etsy shop, GalensTangles.) Plus, learn a few of our favorite tangles for fall!

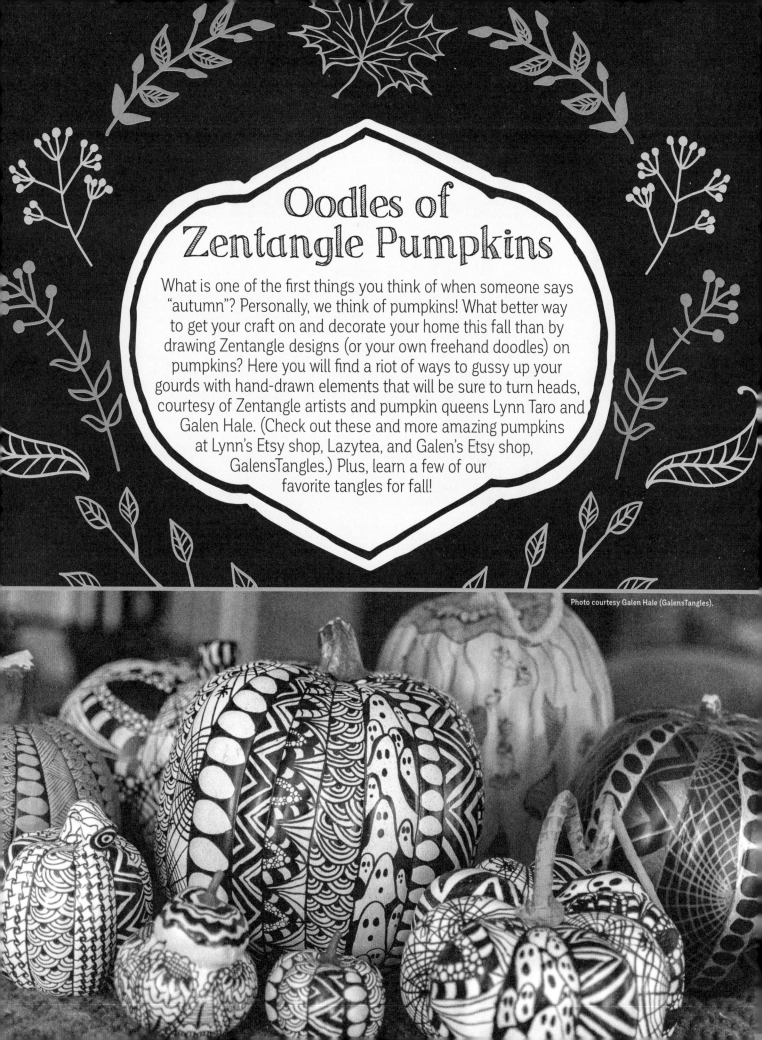

Photo courtesy Galen Hale (GalensTangles).

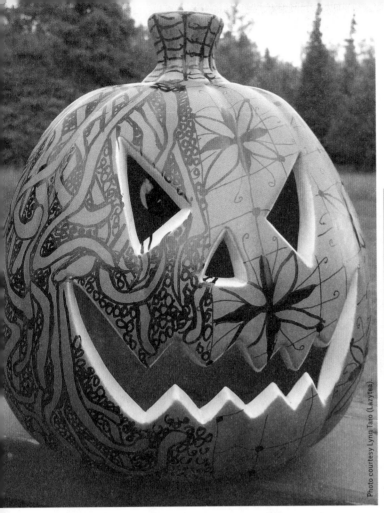

Photo courtesy Lynn Taro (Lazytea).

Go traditional by using black permanent markers on top of a plain orange pumpkin to really accentuate the natural color that we all associate with the season.

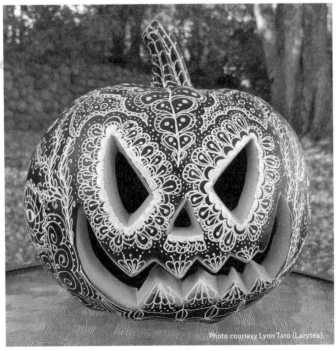

Photo courtesy Lynn Taro (Lazytea).

Try painting your entire pumpkin black and using white paint pens to create a masterpiece full of contrast.

For more information on the Zentangle method, visit *www.zentangle.com* or check out a book on Zentangle, like *Joy of Zentangle* or *Zentangle Basics* (*www.d-originals.com*).

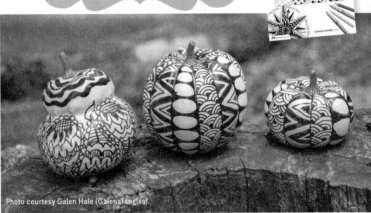

Photo courtesy Galen Hale (GalensTangles).

Increase the fun by using mini pumpkins and gourds—try following the natural shape of each gourd, like you see above.

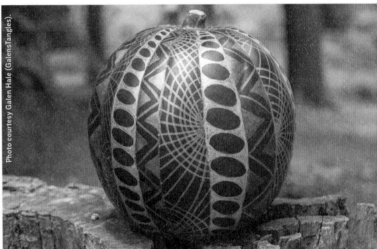

Photo courtesy Galen Hale (GalensTangles).

Go glitzy by using metallic permanent markers to create the patterning on your pumpkins; they will shine beautifully in the afternoon sun.

BARBERPOLE

Tangle by Suzanne McNeill,
Certified Zentangle Teacher (CZT).

Variation

TWILIGHT ZONE

Tangle by Suzanne McNeill, CZT.

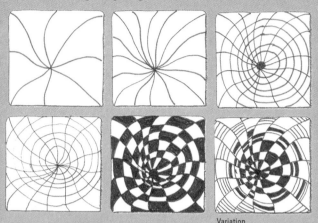

Variation

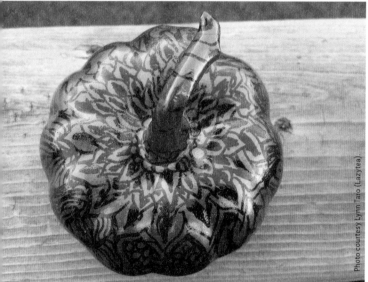

Photo courtesy Lynn Taro (Lazytea).

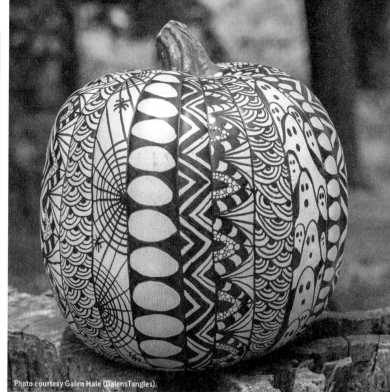

Photo courtesy Galen Hale (GalensTangles).

Try mixing in some Halloween-inspired tangles or doodles, like spiderwebs and ghosts, to really get in the holiday spirit.

WEB

Tangle by Suzanne McNeill, CZT.

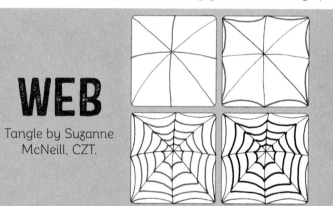

For another metallic look, cover your entire pumpkin in a layer of flashy metallic paint, and then pattern on top of it.

TIP:

Don't feel limited by the time of year or the pumpkin crop at the farm down the road—you can always use artificial pumpkins for your projects, and they will last forever!

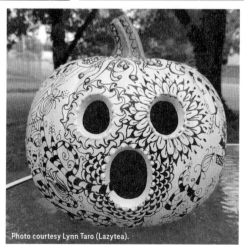

Photo courtesy Lynn Taro (Lazytea).

Incorporate some delicate beads on your carved pumpkin's face and inside different tangles.

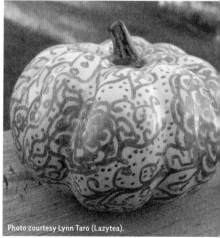

Photo courtesy Lynn Taro (Lazytea).

A white pumpkin with warm brown accents will make your home feel like harvest time.

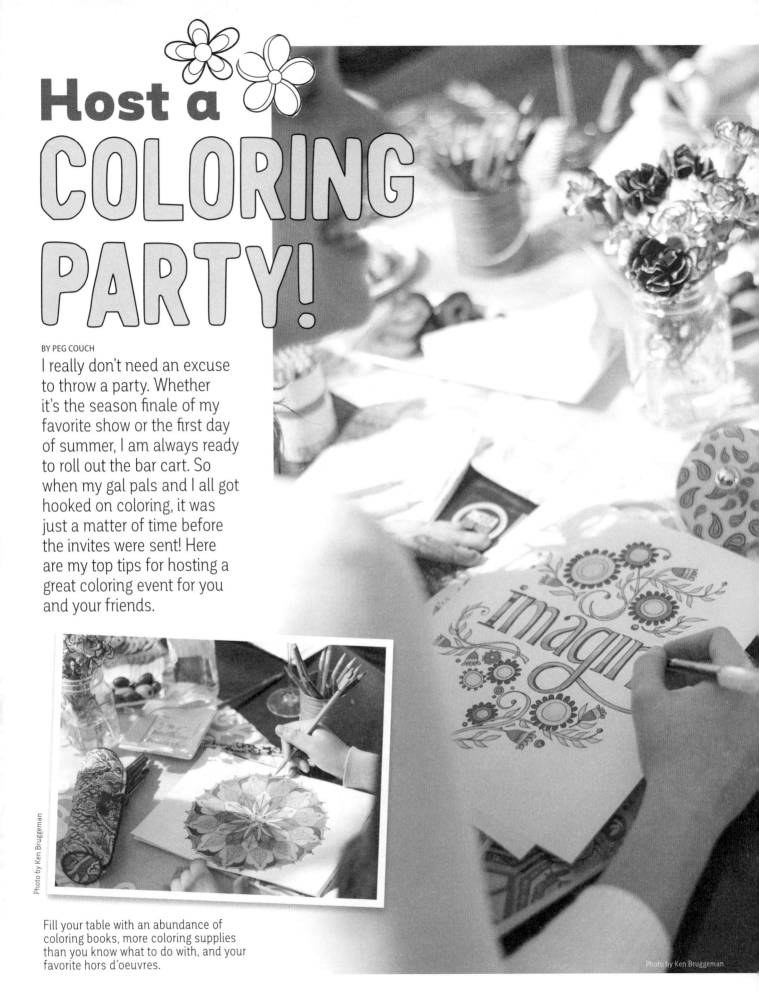

Host a COLORING PARTY!

BY PEG COUCH

I really don't need an excuse to throw a party. Whether it's the season finale of my favorite show or the first day of summer, I am always ready to roll out the bar cart. So when my gal pals and I all got hooked on coloring, it was just a matter of time before the invites were sent! Here are my top tips for hosting a great coloring event for you and your friends.

Photo by Ken Bruggeman

Fill your table with an abundance of coloring books, more coloring supplies than you know what to do with, and your favorite hors d'oeuvres.

Photo by Ken Bruggeman

Invites: You don't need anything formal, just round up your best friends. I'm no Emily Post—a group text or e-mail works for me!

Attendees: Since coloring is a "sit and sip" activity, I recommend you cap your guest list at about 6–8 people (or as many as your dining room table will allow). If you want to invite more people, you can create additional seating with folding tables and chairs.

Supplies: You'll need coloring books and coloring materials. I recommend having one book for every three guests. Most books have perforated pages, making it easy to pull out and share designs. Set out your colored pencils, markers, and gel pens on the table in pretty mason jars or canisters. Ask your guests to bring their own books and coloring supplies—it's not only fun to share, but also a great way to try out new patterns and materials.

TELL EVERYONE TO BRING THEIR FAVORITE COLORING BOOK SO YOU CAN ALL SHARE AND TRY NEW ART!

Snacks: Food is a wonderful way to emphasize the "colorful" theme. Whether you want to go with a rainbow of fresh fruit and vegetables or play up the pink with perfectly frosted cupcakes, have fun with it and be creative. If your girlfriends are like mine, they will all be calling to ask, "What can I bring?" In that case, assign each gal a color and tell her to bring a dish with food in that color.

Beverages: Coloring plus wine...now that's a perfect pair! (Hey—this is "adult" coloring, after all!) Provide red and white to suit all tastes.

Create a Gallery: Find a suitable spot in your home to hang a laundry line art gallery. Have each guest hang their coloring on the line with laundry pins when it's completed. Then, when it's time to go home, guests can take their own designs, or everyone can swap!

Relax and Have Fun: It's fun to prep for a party, but the best part about a coloring soiree is just sitting around the table with a group of your girlfriends and catching up. Life is fast, and coloring helps us slow down and connect with one another.

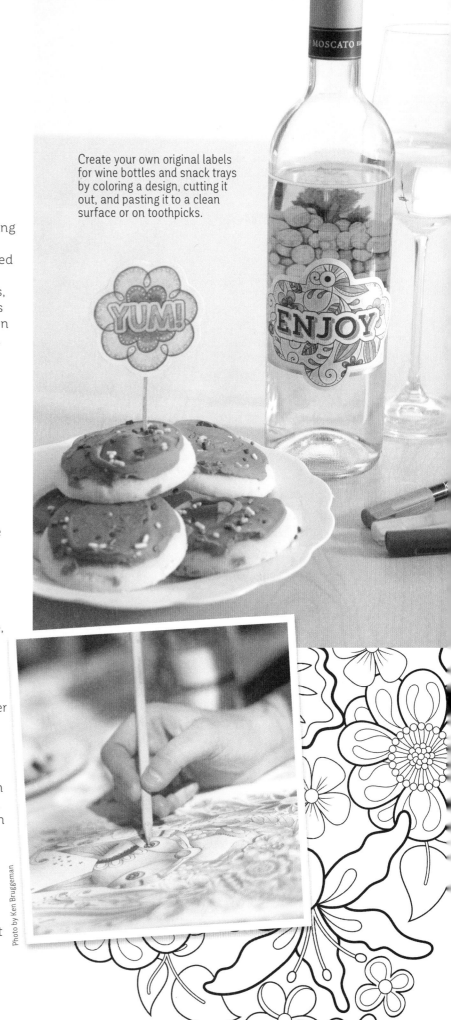

Create your own original labels for wine bottles and snack trays by coloring a design, cutting it out, and pasting it to a clean surface or on toothpicks.

Photo by Ken Bruggeman

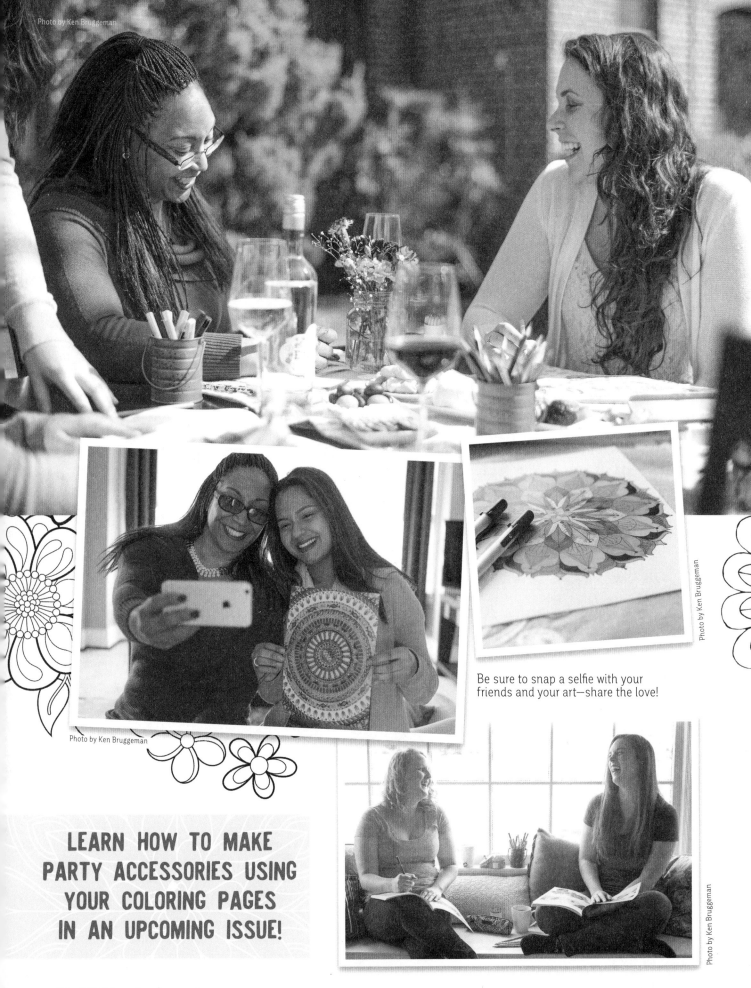

Be sure to snap a selfie with your friends and your art—share the love!

LEARN HOW TO MAKE PARTY ACCESSORIES USING YOUR COLORING PAGES IN AN UPCOMING ISSUE!

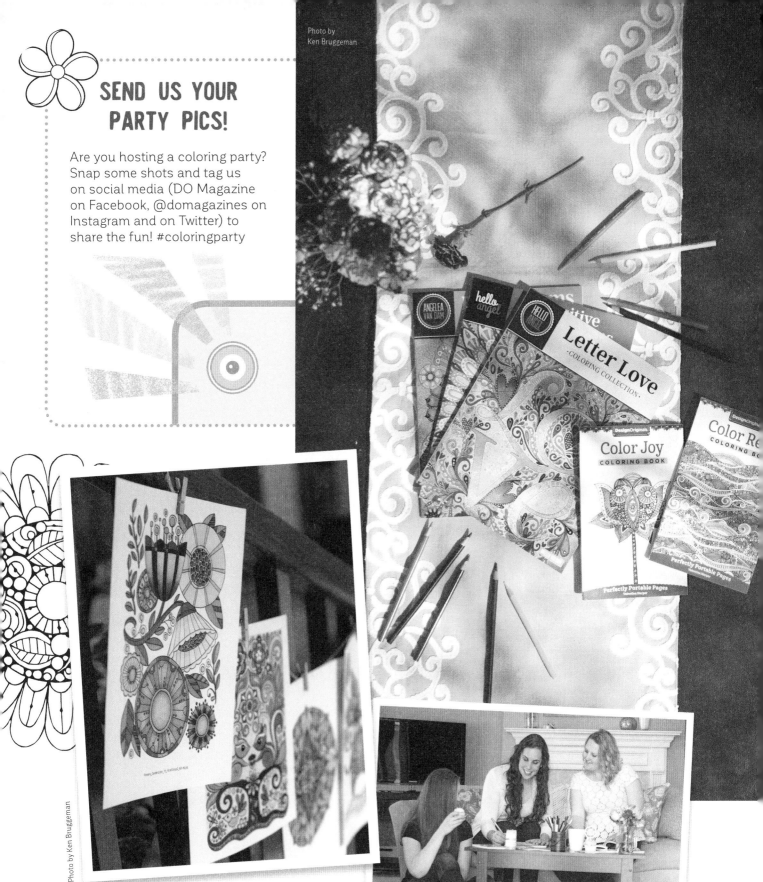

Photo by Ken Bruggeman

SEND US YOUR PARTY PICS!

Are you hosting a coloring party? Snap some shots and tag us on social media (DO Magazine on Facebook, @domagazines on Instagram and on Twitter) to share the fun! #coloringparty

Photo by Ken Bruggeman

Tell everyone to hang their completed art in one place when they're done so at the end of the party, everyone can see the beautiful art they created together!

Photo by Ken Bruggeman

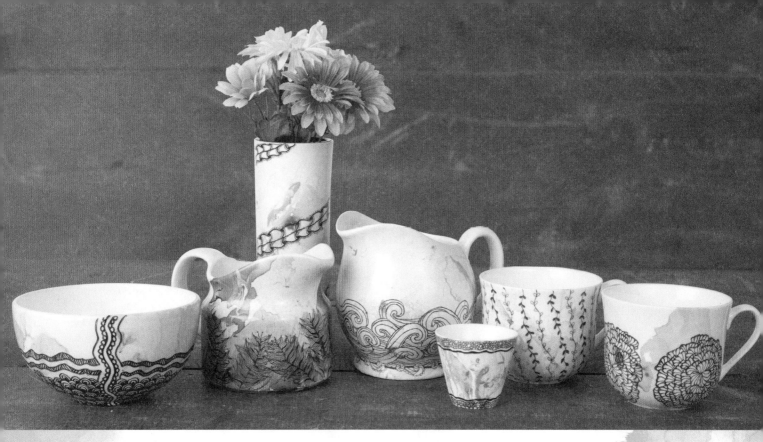

WATERCOLOR
DOODLE MUGS
WITH nail polish!

BY KATE LANPHIER

Impress everyone with this super cool watercolor effect done with a surprising medium—nail polish! You simply drip some nail polish into water and dip your mug or other dish into it. Then you can doodle, draw, or tangle on top of the color with marker.

Materials:

- White mug, vase, or other dish
- Large bowl of water
- Nail polish (newer is better; old and glitter polishes tend to clump)
- Clear spray sealant
- Permanent markers

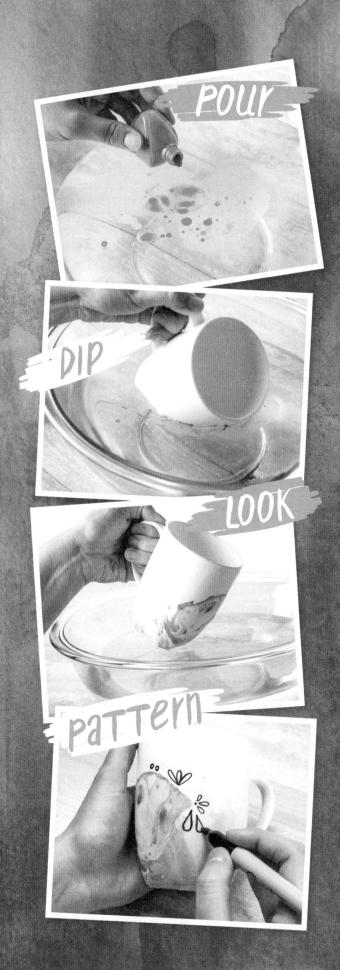

POUR

DIP

LOOK

PATTERN

1. **Dip the dish.** Pour a small amount of your nail polish into the water and wait a few seconds until the color disperses. Take a disposable spoon or other stirrer and swirl it a little, then dip your dish into the water/polish mixture and immediately pull it back out. Dip the dish several times, turning it to get the color where you want it. If you don't like an area on your dish, wipe it off right away, before it starts to dry.

> **Tip:** If you dip your dish into the polish solution and the polish doesn't stick, wait a few more seconds and then try again. If the polish is very clumpy and stringy, you waited too long to dip or your polish is too old.

2. **Layer the colors.** Clean out excess polish from the water by soaking it up with a paper towel, and then repeat the dipping process with your next color. Or, if you put multiple colors into the water at the same time, you can get a more splattered look.

3. **Finish the colors.** Leave the dish out to air dry until the polish is completely dry. Use nail polish remover to remove any polish that got on the inside of your object if you're planning to use the dish for eating or drinking, or if there are stray spots you want to clean up.

4. **Seal and draw.** Spray the dish with a clear sealant—we used Mod Podge clear gloss acrylic sealant—and allow it to dry. Draw or tangle on your dish with a permanent marker or paint marker and re-seal if desired. Enjoy your finished functional work of art, and be sure to hand wash only.

> **Note:** Don't eat or drink anything that touches the colored surface unless you use several thorough coats of a food-safe sealant.

MEET *KC Doodle!*

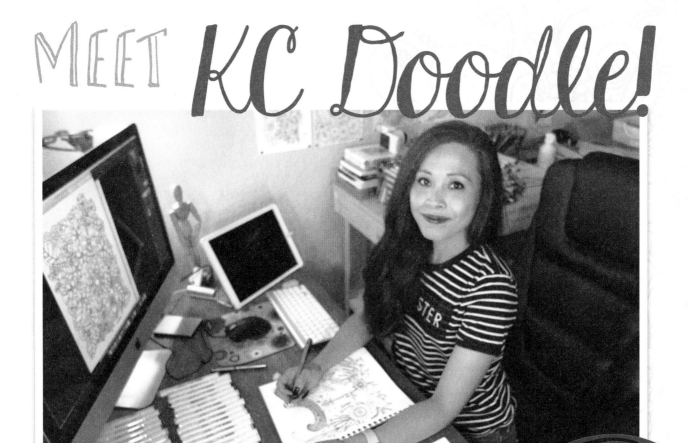

New coloring book author's playful, bright, whimsical designs flow gorgeously on the page

Krisa Bousquet (aka KC), the creator of KCDoodleArt, is one of the newest Design Originals authors, with her books featuring whimsical, magical themes like fairies and flower girls. From her home studio in San Antonio, Texas, this 37-year-old doodling queen runs a popular YouTube channel with more than 21,000 subscribers that records her creations in time-lapse from blank paper to completed design, and she regularly shares her art with her 12,600 (and counting) Instagram followers. We recently caught up with Krisa to get the scoop on what inspires her art, take a peek at her working space, and more!

Check out Krisa's YouTube channel,

with more than 700 awesome time-lapse drawing videos!

And go to *www.domagazines.com* for a handy roundup of the *DO* team's favorite KC Doodle Art videos!

Website: www.kcdoodleart.com
Instagram: @kcdoodleart
Also look for KC Doodle on Twitter, Facebook, Tumblr, and Etsy!

Q&A

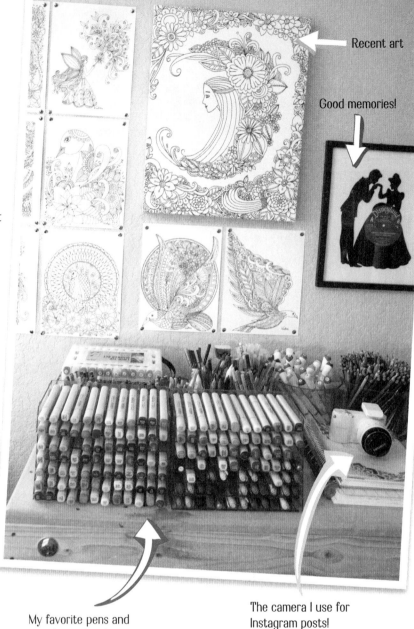

Recent art

Good memories!

Tell us a little bit about you and your background.

I am a Filipina who grew up in a small village in the Philippines. I moved to England with my parents when I was 16, and while in England met my husband, who was stationed there. We now reside in the United States with our two kids and our German shepherd.

How did you decide to make art your livelihood instead of your hobby?

It happened naturally. I was a stay-at-home mom when I discovered doodling and Zentangle art through Pinterest. I decided to try it, and I have been hooked ever since! I doodled and posted on Instagram every single night without fail, and I even created my YouTube channel to show my doodle process. Then some kind of miracle happened! Job opportunities came up, and I grabbed each and every one of them.

What inspires your art?

The world around me is my inspiration. I gravitate toward drawing flowers and the human face. I find them very beautiful.

How would you describe your coloring style?

Eye-catching bright and vivid colors, all on one coloring page.

My favorite pens and pencils are handy

The camera I use for Instagram posts!

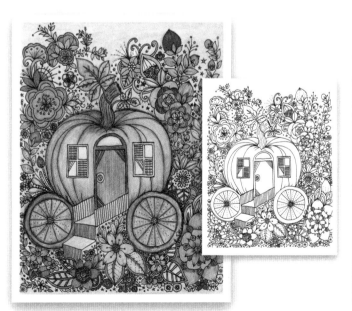

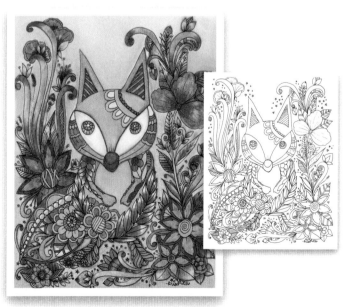

Gotta have my computer!

Bright desk lamp for good lighting

Tripod for filming videos

Free space for doodling

What is your artistic process?

I already have a main subject in mind before I even sit down to draw. I follow it up by sketching on paper with a mechanical pencil. I then trace my pencil guides with black ink.

What types of drawing and coloring tools are your favorites?

Pilot V Razor Point extra fine is my main pen. It is such a pleasure to use this pen, which glides on paper very well. It is also true black and looks very nice on white paper. Not to mention they are cheap! As for markers, I love Copic markers. They are the best markers out there.

What are your must-haves when drawing?

Coffee in the morning, a movie or a TV show playing in the background at all times, and lots of sunlight!

Do you ever work with others or collaborate on pieces?

I did a fun collaboration with YouTube star Tiffany Lovering. I would love to collaborate with other artists. I think it's fun to mix two different styles in one piece.

What are some words to live by?

Do what you love, love what you do!

How would you encourage ordinary people to explore their own creativity?

Always make time for creativity. I know that some of us are busy, but keep a sketchbook with you at all times; that way you can write down ideas that pop into your head. Start with something small and work more on it later, when time allows.

Check out Krisa's four charming new books, all available in September. For more info, see page 83. For instant gratification, go to pages 17, 55, and 89 to color some of Krisa's designs!

Quick Questions with Krisa

What better way for a doodle artist to answer some fun questions than by drawing the answers?

Do you have any pets?

GERMAN SHEPHERD

What kind of music can always make you dance?

HIPHOP

Growing up I wanted to be:

TO BE A POPSTAR

INSTAGRAM @kcdoodleart!
What phone apps are you obsessed with?

Do you speak any other languages?

FILIPINO DIALECTS TAGALOG! BISAYA

What's a cool website you'd recommend?

CREATIVE BLOQ.com FOR ART & DESIGN INSPIRATION

What's your favorite type of restaurant?

MEXICAN RESTAURANT

Describe yourself in one word:
SHY

CHINESE FOOD
What is one food you could never give up?

MEMES
What's been making you laugh lately?

Favorite movie:
♡THE COUNT OF♡ ♡MONTE♡ CRISTO

What do you do to relax?

READING & DOODLING

Favorite book:

HARRY POTTER

You would always find ___ in my refrigerator:

CHEESE

Your hobbies:
♡DRAW♡DOODLE

EXPRESS YOURSELF!

Art Journaling Provides a Creative Outlet That Goes Beyond Words

BY KATY ABBOTT

Art journaling has always been a part of the craft world, but with the emergence of the coloring and doodling trends, it is coming into the spotlight as people around the world seek new methods for creativity and expression. Art journaling is a creative way of experimenting and expressing yourself using a journal—and anyone can do it. Art journaling is great for so many reasons: it provides a way to test ideas to see what you like and don't like; it's portable, so you can take it anywhere and share it with others; and it acts as a visual diary for your personal thoughts. The best thing about art journaling, though, is there is no right or wrong way to do it. I do not have formal training in art, so I use my journal as a place to play with color and texture. Sometimes I want to capture a favorite quotation, try out a new technique, or write about a difficult situation and then paint over my words. I am delighted by some of my pages, and I learn from pages that don't quite end up how I had intended. Art journaling is not about perfection, it's about creative expression. Now that I've been working on art journals for a few years, I feel energized, buoyant, and confident after I've created a page.

GETTING STARTED

As with most things, starting is the hardest part. Here's how I would encourage you to take the plunge:

1. First, silence that inner critic who can keep you from trying new things. **Give it a try** and embrace the process!

2. Give yourself permission to **make mistakes** and to make pages you don't like. That's the point of experimenting! You will learn as you go.

3. **Use supplies you have on hand**: markers, crayons, craft paints, watercolors, whatever! You don't need anything fancy to get started.

4. Pick a journal that is not *precious* to you so you can **dive in and make a mess**. I prefer to use journals labeled for mixed media (90 lb. weight paper) because you can use wet media without worrying about the pages tearing.

5. Set aside some time each day. I have a full-time job and am not able to spend as much time on my art journal as I would like, but I **try to do a little something most days**, even if it's opening a new page and adding a background layer. Background layers are fun to do, get rid of the white page, and wait patiently for you to come back to them.

I know if you open a journal and put pen to paper you will not regret it, and you will have a blast experimenting and exploring your creativity. To help you on your journey, I've included in this article two of my favorite methods for creating a background on a journal page. There are many resources available if you want to learn more, including gobs of videos on YouTube! Plus, check out my list of inspiring art journalers at the end of this article. I hope you are able to grow and learn as much as I have through keeping an art journal. Have fun!

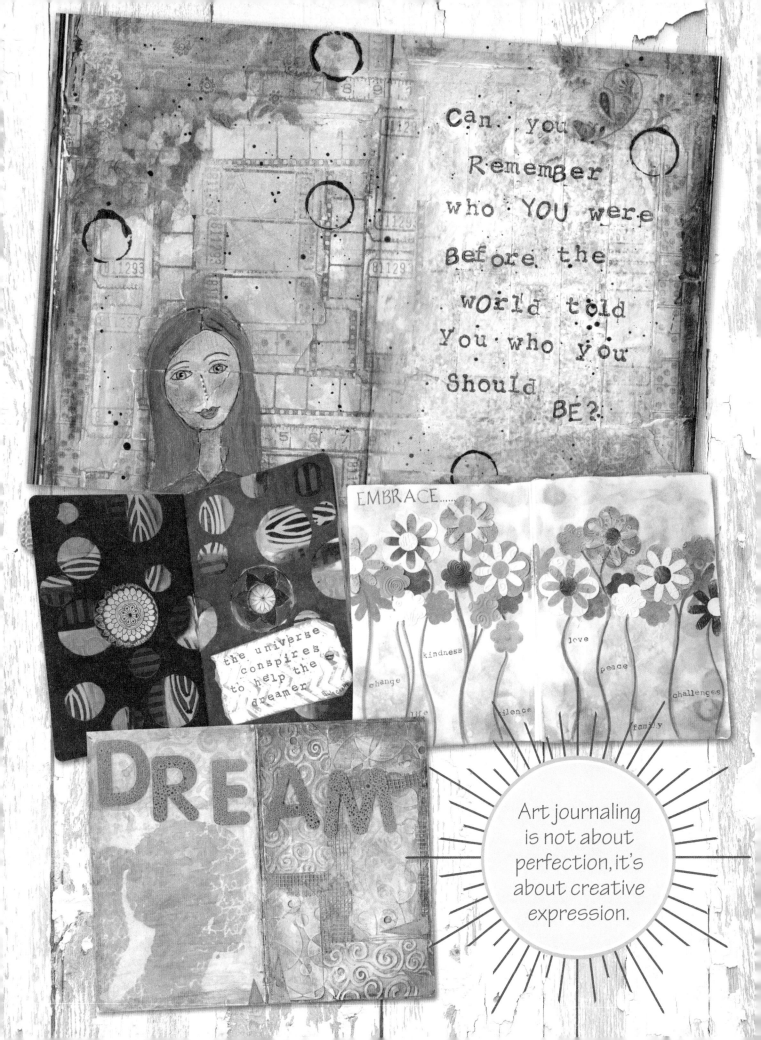

Can you Remember who YOU were Before the world told You who You Should BE?

EMBRACE......

change
kindness
love
peace
challenges
life
silence
family

the universe conspires to help the dreamer

DREAM

Art journaling is not about perfection, it's about creative expression.

MASKING TAPE TEXTURE BACKGROUND

This background is so easy to create, and it will give your finished page amazing dimension and texture. Grab a roll of masking tape and rip small pieces off and stick them on your journal page in a random fashion. Vary the length of the strips, and try to get some roughly torn edges. You can even tear the tape in half lengthwise to create some different widths. Continue applying the tape pieces, overlapping them until the page is mostly covered. Then add paint, stencil images, or rubber stamping! For a really cool effect, apply markers or watercolors over the masking tape, and then close your journal to stamp the opposite page with the masking tape texture.

RESIST BACKGROUND

You can also use tape to create a resist background. Place strips of tape over the center of your journal page, leaving a generous margin around the edges. Decorate the margin with patterning, coloring, a background wash, or any other design you choose. Then remove the tape and use the open space left behind for journaling. This method works best with washi tape because the light adhesive will not tear your journal paper when you remove it.

BOOK PAGE BACKGROUND

Book pages or other printed paper, like sheet music, can make really interesting backgrounds for a journal design. Stop by a local thrift store or your public library's used book sale to pick up inexpensive books, or print pages from your favorite novel so you don't have to remove them from the book itself. Tear the book page into small pieces and glue them onto your journal page randomly. You can use the pieces to cover the entire page, just a portion of the page, or just the margins— it's up to you! Place some pieces upside down or sideways. You can also overlap the edges for more texture. Work quickly and glue the pieces down within a few seconds of picking them up—this will keep you from overthinking it! Once the pieces are glued down, add paint, stencil images, or rubber stamping.

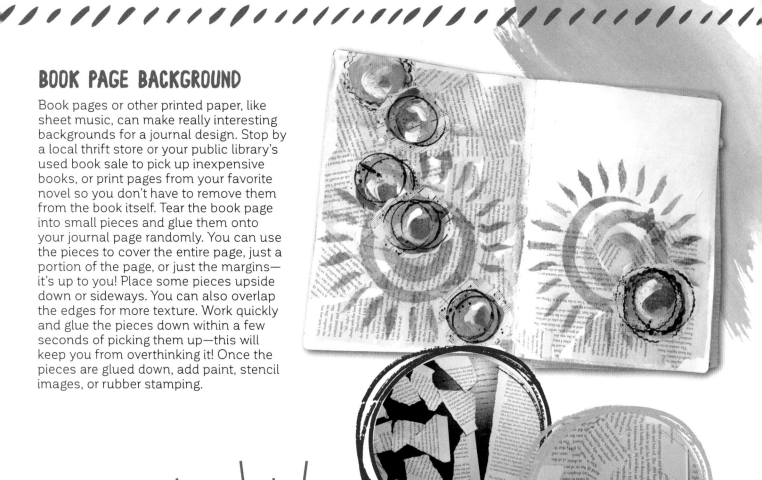

GET INSPIRED!

I'd love to see your art journaling work and answer your questions! Contact me at *katy.abbott@icloud.com* or via Facebook (*www.facebook.com/AbbottArtistry*). And be sure to check out these other great resources for art journaling inspiration:

- Diana Trout (author of *Journal Spilling*), www.dianatrout.typepad.com
- Julie Fei-Fan Balzer, www.balzerdesigns.typepad.com
- Terri Sproul, www.terrisproul.blogspot.com
- Dina Wakley (author of *Art Journal Freedom* and *Art Journal Courage*), www.dinawakley.com
- Carolyn Dube, www.acolorfuljourney.com
- Journal Fodder Junkies (David R. Modler and Eric M. Scott), www.journalfodderjunkies.com

PERFECTLY PORTABLE COLORING

Colored Pencils & Sharpener Tube

Take your creativity on the go! With *DO Magazine*'s handy **Colored Pencils & Sharpener Tube**, you'll always be ready to color, tangle, craft, and doodle!

- Durable, Travel-Friendly Case
- High-Quality Colored Pencils
- 12 Assorted Colors
- Built-In Pencil Sharpener

$7.99 • UPC: 023863-08021-7

Pencil colors may vary

Conveniently sized at 5.25" x 8.25", these on-the-go coloring books fit easily in your pocket or purse. They're great to use in waiting rooms, during lunch break, at kids' soccer practice, or wherever you can find a few precious moments of downtime!

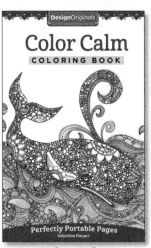

Color Calm Coloring Book
By Valentina Harper
$4.99 • 978-1-4972-0033-3

Color Animals Coloring Book
By Jess Volinski
$4.99 • 978-1-4972-0239-9

Color Inspiration Coloring Book
By Suzy Toronto
$4.99 • 978-1-4972-0161-3

Color Love Coloring Book
By Thaneeya McArdle
$4.99 • 978-1-4972-0035-7

ORDER TODAY! 800-457-9112 • www.D-Originals.com

COLOR YOUR WAY TO HAPPINESS!

KC Doodle Art Coloring Collections

BY KRISA BOUSQUET

Social media trendsetter Krisa Bousquet started drawing her magical illustrations as a simple way to pass the time. But drawing quickly grew from hobby to obsession as her art grew more complex, detailed, and refined. As the creator of KC Doodle Art, with thousands of fans on Etsy, Pinterest, Instagram, Tumblr, and her popular YouTube channel, Krisa's biggest influences are the world around her—especially flowers, nature, and the human face. Her relaxing coloring books will take you to a captivating world of lush foliage and beautiful people, ready for easy or advanced coloring depending on your mood!

KC Doodle Art Fairies Coloring Book
$9.99 • Code: DO5746
Available September 2016

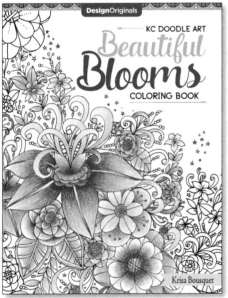

**KC Doodle Art Beautiful Blooms
Coloring Book**
$9.99 • Code: DO5745
Available September 2016

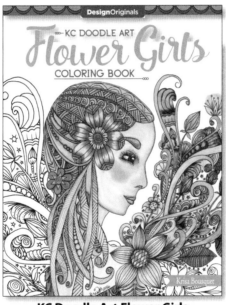

**KC Doodle Art Flower Girls
Coloring Book**
$9.99 • Code: DO5744
Available September 2016

**KC Doodle Art Fantasy Garden
Coloring Book**
$9.99 • Code: DO5747
Available September 2016

DO Magazine artist
FAIR TRADE
SEAL OF APPROVAL
guarantee
COLOR TANGLE CRAFT DOODLE

Hello Angel Positive Inspirations Coloring Collection
$9.99 • 978-1-4972-0145-3

Hello Angel Letter Love Coloring Collection
$9.99 • 978-1-4972-0143-9

Hello Angel Big Blossoms Coloring Collection
$9.99 • 978-1-4972-0142-2

Hello Angel Majestic Animals Coloring Collection
$9.99 • 978-1-4972-0144-6

Hello Angel Mindfulness Coloring Collection
$9.99 • 978-1-4972-0140-8

Color This! Birds & Animals Coloring Book
$9.99 • 978-1-4972-0172-9

Color This! Doodle Patterns & Designs to Color
$9.99 • 978-1-4972-0171-2

TangleEasy Meaningful Mandalas and Sacred Symbols
$14.99 • 978-1-4972-0029-6

TangleEasy Wildlife Designs
$14.99 • 978-1-4972-0027-2

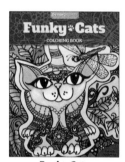

Funky Cats Coloring Book
$9.99 • 978-1-4972-0153-8

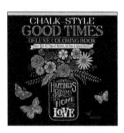

Chalk-Style Good Times Deluxe Coloring Book
$14.99 • 978-1-4972-0152-1

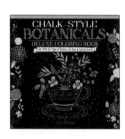

Chalk-Style Botanicals Deluxe Coloring Book
$14.99 • 978-1-4972-0151-4

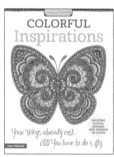

Colorful Inspirations
$9.99 • 978-1-4972-0111-8

Modern Flowers Coloring Book
$9.99 • 978-1-4972-0000-5

Stylized Animals Coloring Book
$9.99 • 978-1-4972-0162-0

Friendship Coloring Book
$9.99 • 978-1-4972-0155-2

Inspiration & Encouragement Coloring Book
$9.99 • 978-1-4972-0157-6

Light & Laughter Coloring Book
$9.99 • 978-1-4972-0156-9

Expressions of Faith Coloring Book
$9.99 • 978-1-4972-0083-8

Flowers of Faith Coloring Book
$9.99 • 978-1-4972-0134-7

BOOKS FOR COLORING CREATIVITY

Seek, Color, Find Cheerful Words and Sayings
$9.99 • 978-1-4972-0148-4

Seek, Color, Find Garden
$9.99 • 978-1-4972-0147-7

Don't Worry, Be Happy Coloring Book Treasury
$19.99 • 978-1-4972-0022-7

Fun & Funky Coloring Book Treasury
$19.99 • 978-1-4972-0021-0

Ultimate Coloring Book Treasury
$19.99 • 978-1-4972-0024-1

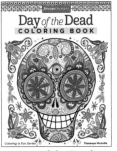

Day of the Dead Coloring Book
$9.99 • 978-1-57421-961-6

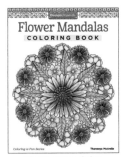

Flower Mandalas Coloring Book
$9.99 • 978-1-57421-994-4

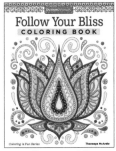

Follow Your Bliss Coloring Book
$9.99 • 978-1-57421-996-8

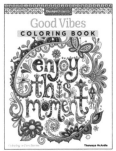

Good Vibes Coloring Book
$9.99 • 978-1-57421-995-1

Happy Campers Coloring Book
$9.99 • 978-1-57421-965-4

Nature Mandalas Coloring Book
$9.99 • 978-1-57421-957-9

Peace & Love Coloring Book
$9.99 • 978-1-57421-963-0

Creative Coloring Animals
$9.99 • 978-1-57421-971-5

Creative Coloring Birds
$9.99 • 978-1-4972-0003-6

Creative Coloring Botanicals
$9.99 • 978-1-4972-0004-3

Creative Coloring Mandalas
$9.99 • 978-1-57421-973-9

Creative Coloring Flowers
$9.99 • 978-1-57421-970-8

Creative Coloring Mandala Expressions
$9.99 • 978-1-4972-0005-0

Creative Coloring Inspirations
$9.99 • 978-1-57421-972-2

Creative Coloring A Second Cup of Inspirations
$9.99 • 978-1-4972-0112-5

DESIGN ORIGINALS

By Phone: 800-457-9112 • **Direct:** 717-560-4703
Fax: 717-560-4702
Online at: www.FoxChapelPublishing.com
By Mail: Send Check or Money Order to
Fox Chapel Publishing
1970 Broad St.
East Petersburg, PA 17520

# Item	Shipping Rate
1 Item	$3.99 USD
Each Additional	.99 USD

Canadian & International Orders - please email info@foxchapelpublishing.com or visit our website for actual shipping costs.

VISA • MasterCard • Discover NOVUS

Contributors

Marie Browning

Marie Browning has inspired crafters internationally with her vast knowledge of products and techniques. She is the best-selling author of more than 30 crafting books and has more than 2 million books in print. Her books are available worldwide and printed in numerous languages. Marie's book *Time to Tangle with Colors* features techniques for coloring Zentangle art using Tombow's Dual Brush Pens. Marie writes articles for national craft magazines, teaches hands-on classes, provides live demonstrations, and appears on TV and in videos. *www.mariebrowning.com*

Katy Abbott

Katy Abbott is an Assistant Professor of Gerontology at Miami University in Oxford, Ohio, and enjoys making things in her spare time. In addition to art journaling, Katy makes glass beads with a torch, and is a Certified Zentangle Teacher. Her work has been featured on HGTV and PBS as well as in numerous books and magazines. Katy enjoys bringing her academic and creative lives together to teach Zentangle to individuals with dementia and caregivers. *www.abbottglassdesigns.blogspot.com*

Nour Tohmé

Nour Tohmé is a French-Lebanese illustrator and graphic designer living in Paris. As a master's degree student, she developed an interest in hand-lettering and illustration, and began experimenting with both. She started creating music-inspired artwork in which she combined hand-lettered typography and illustration to depict lyrics of famous songs. The resulting blend of music and visual art quickly garnered attention and an online following, which pushed Nour to develop the idea into a real, creative business, Draw Me a Song. The project went on to receive several awards for creative entrepreneurship. Nour now runs her Draw Me a Song shop and works as a freelance illustrator and graphic designer. *www.nourtohme.com*

Krisa Bousquet

Krisa Bousquet (or KC), the creator of KCDoodleArt, began drawing as a simple way to pass the time. This quickly grew from hobby to obsession to full-time job as her art grew more complex, detailed, and refined. From her home studio in San Antonio, Texas, she runs a popular YouTube channel with more than 21,000 subscribers, and she regularly shares her art with her 12,600 (and counting) Instagram followers. *www.kcdoodleart.com*

Kati Erney

Kati Erney works on staff at *DO Magazine*, where she spends an unsurprising number of hours crafting. She loves to color in vibrant hues and striking, symmetrical patterns. Some of her favorite things include reading books and creating art for home decoration, which makes working at *DO Magazine* a dream.

Llara Pazdan

Llara Pazdan works on staff at *DO Magazine*, crossing into many departments from editorial to design. With a background in advertising, her passion for all things crafting has brought her artwork away from the computer screen and back into her marker-stained hands. She enjoys being outdoors and exploring antique markets for craft/upcycle ideas, which she loves to share here at *DO*.

Kate Lanphier

Kate Lanphier works on staff at *DO Magazine*, designing articles and directing photo shoots. With a background in graphic design and fine arts, she loves to craft and share her creations with the world through print. She is always searching Pinterest for new craft and upcycling ideas for her own home and to share with *DO Magazine* readers!

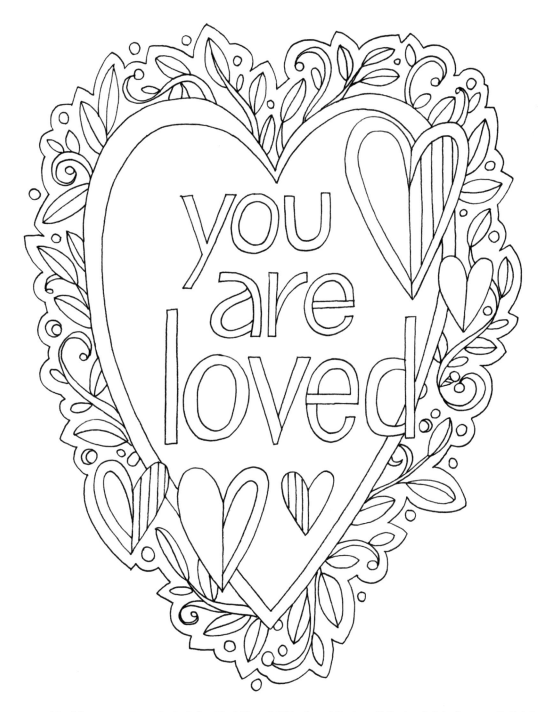

The gray border used for this design allows the blues to really pop.

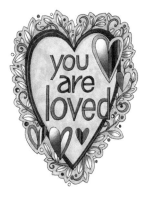

This page is a special SEEK, COLOR,
FIND page! Look for this ice cream icon
hidden within the art.

You Are Loved Heart

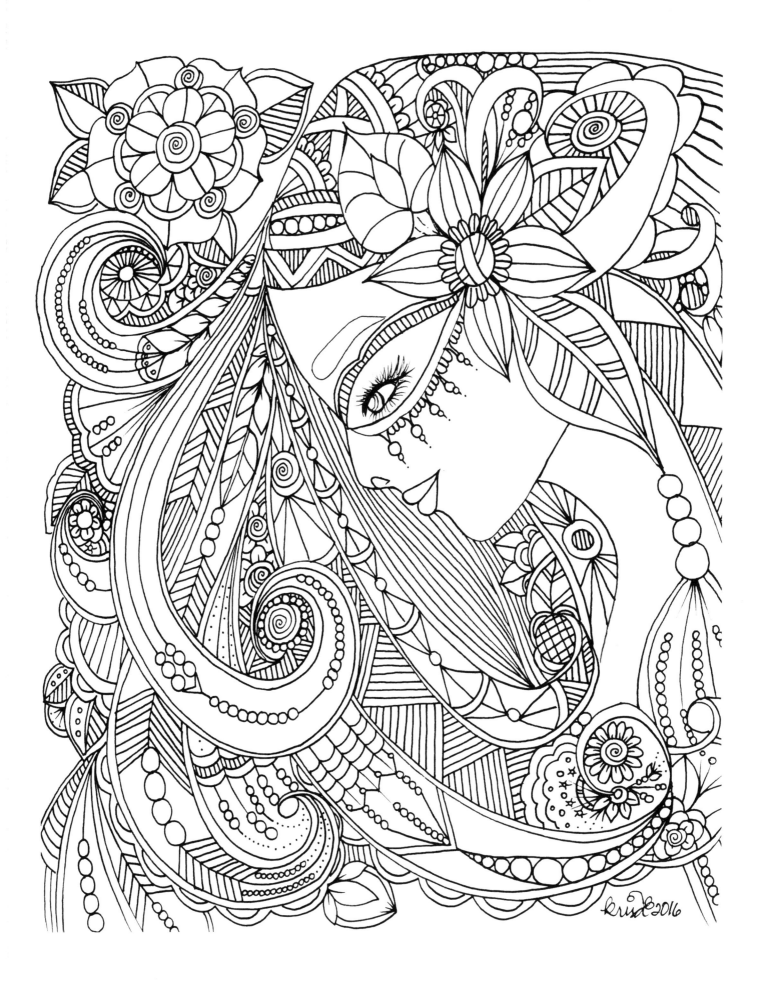

Beauty is not in the face; beauty
is a light in the heart.

—Kahlil Gibran

Masked Beauty

Mimosa

Old Fashioned

Mojito

Margarita

Let yourself be silently drawn by the strange pull of
what you really love. It will not lead you astray.

—Rumi

Flower Arch

I've always liked the time before dawn
because there's no one around to remind
me who I'm supposed to be, so it's easier
to remember who I am.

—Brian Andreas

Hello Angel #1201

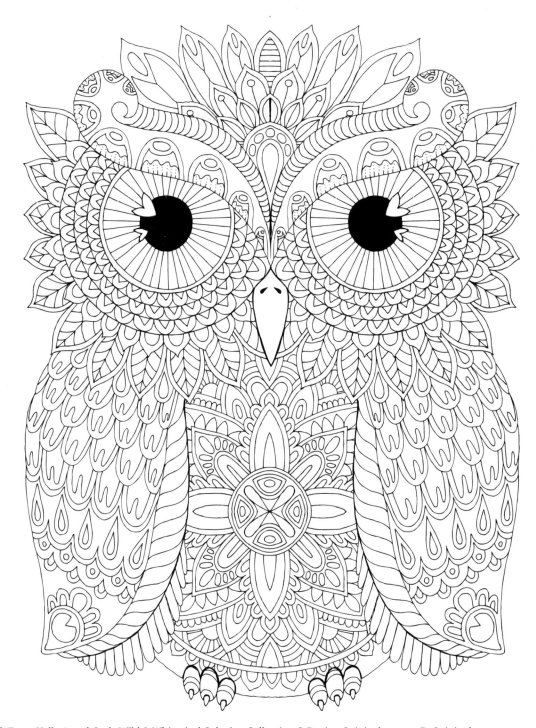

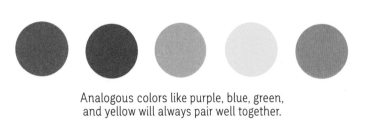

Analogous colors like purple, blue, green,
and yellow will always pair well together.